**The Designer's
Dictionary of Type**

The Designer's Dictionary of Type

Sean Adams

ABRAMS, NEW YORK

© 2019 Quarto Publishing plc
For The Bright Press
Text and design: Sean Adams
Editors: Jacqui Sayers and Emily Angus
For Abrams
Editors: John Gall and Ashley Albert
Production Manager: Lindsay Bleemer

ISBN: 978-1-4197-3718-3
eISBN: 978-1-68335-590-8

Printed and bound in China
10 9 8 7 6 5 4 3 2 1

Abrams books are available at special
discounts when purchased in quantity
for premiums and promotions as well as
fundraising or educational use. Special
editions can also be created to specifica-
tion. For details, contact specialsales@
abramsbooks.com or the address below.
Abrams® is a registered trademark of
Harry N. Abrams, Inc.

195 Broadway
New York, NY 10007
abramsbooks.com

"Someday I'll design a typeface without a 'K' in it, and then let's see the bastards misspell my name."

— FREDERIC GOUDY

Contents

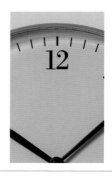

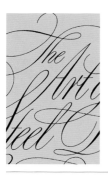

The York
Theater Group
James Bullitt's
The Great Basin
The York Theater
June 24–July 5

6045 W Temple St., Los Angeles, California 90012
www.yorktheatergroup.com

Pictures of Words

OPPOSITE
The Great Basin
Sean Adams - 2018
Poster
The graphic system for the York Theater Group is simple: full-bleed photography and Neue Haas Grotesk Bold. Rather than adopting a traveling production's existing poster, the images represent the content of the production. The typography is consistently the same size, weight, and style.

TYPEFACES CREATE PICTURES OF WORDS. Like images, each typeface communicates an idea, emotion, and point of view. Helvetica might speak to neutrality and information; Garamond can read as literary and classic; Bodoni feels sophisticated, urbane, and crisp.

The choice of typeface communicates a subtle message to the viewer. The typeface choice, like a moving and powerful photograph, is the difference between a good idea expressed adequately and a good idea expressed persuasively.

There are as many approaches to typeface choice as there are design processes. Some designers, such as Massimo Vignelli, work with a small handful of typefaces for their entire career. Other designers may be more promiscuous with type, switching typefaces on every project. Neither of these is wrong. Vignelli adhered to strict modernist principles of simplicity and reduction. Herb Lubalin designed his own typefaces, preferring variety, flourish, and drama. These examples are extremes; many designers operate closer to the center of the spectrum.

This book is not a comprehensive analysis and history of every typeface. Such an undertaking would require several volumes, each one thousands of pages thick. *The Designer's Dictionary of Type* provides historical and contextual examples of interesting multimedia applications of each typeface. Typeface classifications such as serif and sans serif divide the book. Styles such as transitional and modern divide each classification. A diagram for easy identification of each typeface will help the reader determine if he or she is looking at Bembo or Baskerville.

The Designer's Dictionary of Type aims to illustrate the multiple ways in which a designer might apply a typeface, as well as the many variations of each one. With experience, a designer will be able to look at a version of Caslon and determine whether it is well-crafted and refined, or a cheap knock-off from a free download.

My advice to designers throughout my career has been to work with the classics represented in this book. They are classics for a reason, and they are timeless. I also advise designers to think of typefaces like haircuts. One does not want to choose the latest, grooviest, trendiest style and years later be embarrassed by the sight of one's high-school portrait.

Type Classifications

Blackletter

Refers to a calligraphic style based on handwritten manuscripts before the invention of the movable type press and movable metal type.

Decorative

Another term applied to display typefaces. These can also include complex Victorian and hand-drawn letterforms.

Digital

A digital typeface is typically designed for use on the screen or with new technologies. However, these also include typefaces designed in a digital environment to challenge traditional typeface dictates.

Didone

Didone is a typeface classification characterized by letterforms with strong contrast between thick and thin lines. Typically, horizontal parts of letters are thin in comparison to the vertical strokes.

Display

A display typeface is utilized for headlines and large body copy. It is not legible as small text. Display typefaces are often elaborate or rely on extreme contrast.

ABCDEFGI
abcdefghijk
1234567890

A

Egyptian

Egyptian typefaces, also called "slab serif," have heavy, square-ended serifs. They derived from the need for strong and durable large wood type letterforms.

a

Geometric Sans Serif

Geometric sans serif typefaces are based on simple geometric shapes. For example, the letter "O" will be a circle, and a "V" will be based on simple diagonal forms.

RIGGING

a

Grotesque

Grotesque typefaces have nineteenth-century origins. These sans serif typefaces have more variation in their thick and thin strokes and may seem more industrial than refined.

Type Classifications

Humanist

Humanist typefaces are based on the proportions of classical Roman inscriptions. They are sans serif typefaces with less uniformity and a "warm" tone.

Modern

A modern typeface is not a contemporary typeface. It is a style developed in the late eighteenth century as a new form different from the old style typefaces.

Monospaced

Monospaced typefaces were first designed for typewriters. Each letterform is mathematically the same width.

Neo-Grotesque

Following the popularity of grotesque typefaces, neo-grotesque typefaces have more uniform stroke weights and appear more contemporary and refined.

a Old Style

Old style typefaces are based on letterforms designed by Renaissance typographers to replace the heavy blackletter style.

a Sans Serif

A sans serif typeface does not have any serifs. The word "sans" is based on an Old French term, *sanz*, meaning "without."

a Serif

A serif is a projection on the end of some strokes of letters and symbols. A typeface that has serifs is identified as a serif typeface.

a Slab Serif

Slab serif typefaces, also called "Egyptian," have heavy, square-ended serifs. They derived from the need for strong and durable large wood type letterforms.

Serif

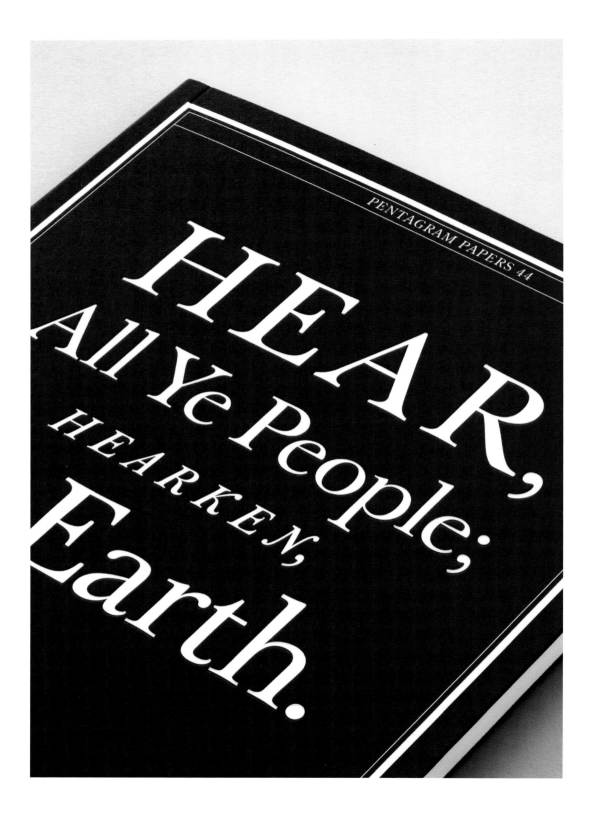

Baskerville

Designer: John Baskerville (1707–1775)
1775: London, UK

Modern Versions:
Baskerville SB, 2004
Bitstream Baskerville
Linotype Baskerville, 2012
Monotype Baskerville, 2001
URW Baskerville, 2000

John Baskerville lived and worked during the Age of Enlightenment, a philosophical movement that embraced reason and rejected the dogma of the Roman Catholic Church. His typeface Baskerville incorporated the ideals of the Enlightenment, making it one of the first transitional typefaces. John Baskerville's goal was to improve on William Caslon's work. The result is a typeface free of calligraphic imitation, with circular curves and vertical strokes. The italic version was closely related to the roman version. This was a milestone, as previous italics often had little connection to their roman counterparts.

Baskerville endeavored to print higher-quality books than the mass-produced volumes of lesser quality. He worked with high-end and well-maintained presses, high-quality ink, and smooth paper. The typeface Baskerville was perfectly suited for use with these superior methods.

SUGGESTIONS FOR SUCCESSFUL APPLICATION

➼ There are many versions of Baskerville available. Baskerville 10 is thicker and is better suited to a screen-based environment.
➼ Fry's Baskerville has sharp serif forms and delicate strokes. Use this version only for headlines.

BASKERVILLE

» TRANSITIONAL SERIF

APPLICATIONS
Sports Authority logo
The Door in the Wall book, by H. G. Wells
The Ritz-Carlton branding
Mother & Child logo

SIMILAR
Caslon
Mrs. Eaves

OPPOSITE
Pentagram Papers 44: Hear, All Ye People: Hearken, O Earth
Michael Bierut, Jessica Svendsen: Pentagram - 2013
Publication
In 2012, Errol Morris published a quiz in *The New York Times* to determine if typefaces matter; Pentagram Papers 44 presents the results. These revealed Baskerville to be the most believable typeface among Computer Modern, Georgia, Helvetica, Comic Sans, and Trebuchet.

HEAR,
All Ye People;
HEARKEN,
O Earth.

An **EXPERIMENT** to
DISCOVER THE MOST
TRUSTWORTHY
Typeface.

ERROL MORRIS.

with BENJAMIN BERMAN *and* DAVID DUNNING.

Pentagram Papers 44:
Hear, All Ye People: Hearken, O Earth
Michael Bierut, Jessica Svensden:
Pentagram - 2013
Publication
The title page for the publication references
eighteenth-century British symmetrical
design and typography.

Installation of Dwight David Eisenhower
Melvin Loos - 1948
Program cover
The program cover for Eisenhower's
installation as the President of Columbia
University utilizes true small capitals. True
small caps are slightly extended and a thicker
weight for optical clarity.

COLUMBIA
UNIVERSITY

INSTALLATION OF

DWIGHT DAVID EISENHOWER

AS THIRTEENTH PRESIDENT

OCTOBER 12, 1948

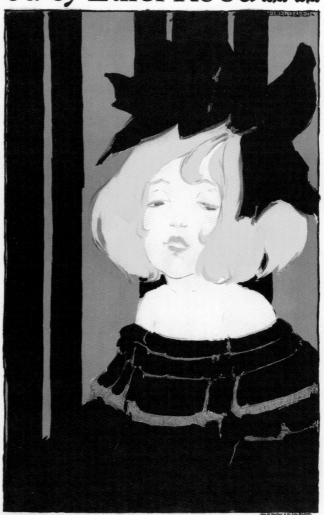

In Childhood's Country
Ethel Reed ~ 1896
Poster
To promote the book *In Childhood's Country,*
Ethel Reed illustrated an image of a young
girl in a style derived from Japanese
woodblock prints. The typography is a hand-
drawn version of Baskerville.

BELOW
The Metropolitan Opera
Paula Scher: Pentagram ~ 2012
Identity
Paula Scher's identity for the Metropolitan
Opera highlights the common nickname, the
Met Opera, in a compact, classic wordmark.
Baskerville alludes to the opera's classical
nature with a modern touch.

The **Met**
ropolitan
Opera

THE PENGUIN SHAKESPEARE

*The Second Part
of Henry the Fourth*

Edited by G. B. Harrison

One shilling and sixpence

PENGUIN BOOKS

Bembo

Designer: Francesco Griffo (1450–1518)
1495: Venice, Italy

Modern Versions:
Monotype Bembo, 1929

In 1496, the Venetian printer Aldus Manutius produced a more delicate version of a roman typeface developed by Francesco Griffo. He applied it to a short piece by the poet Pietro Bembo. The capital letters are based on the letterforms from classical Roman monuments. The typeface was developed as an evolution from blackletter types based on hand-drawn calligraphic letters. Twentieth- and twenty-first-century versions of Bembo are designed with more refined forms to be more consistent and less calligraphic.

Bembo is especially successful as a text typeface. Designers and printers have applied Bembo as body copy in books and printed publications for five centuries. As a result, most readers are comfortable with it, and it provides a seamless reading experience.

SUGGESTIONS FOR SUCCESSFUL APPLICATION
- ➺ Bembo's x-height is smaller than other serif typefaces. Set body copy one point larger than it would be in a typeface such as Caslon.
- ➺ The italic version is rather condensed. Allow for extra letterspacing to improve legibility.

APPLICATIONS
Maserati branding
University of Maryland logo
Penguin Classics book covers

SIMILAR
Garamond Roman
Centaur
Poliphilus

OPPOSITE
The Second Part of Henry the Fourth
Jan Tschichold - 1956
Book cover
Jan Tschichold is one of the twentieth century's most influential modernist typographers. But after fleeing Nazi Germany, he deemed asymetical modernism in typography as fascist. His work at Penguin Books reflects his turn toward symmetrical classicism.

BELOW
Llavors Negre
Senyor Estudi ~ 2014
Wine label
The text on the label is from the book *Rere els murs*, by Núria Esponellà. The story is set during the construction of the Monastery of Sant Pere de Rodes in the winemaking Empordà region of Spain.

OPPOSITE
Little Flower
Sean Adams ~ 2017
Identity
Little Flower is a bakery, candy company, and café. The identity references the "flower" as a meeting place or tables seen from above. Bembo provides a clear and classical tone.

24

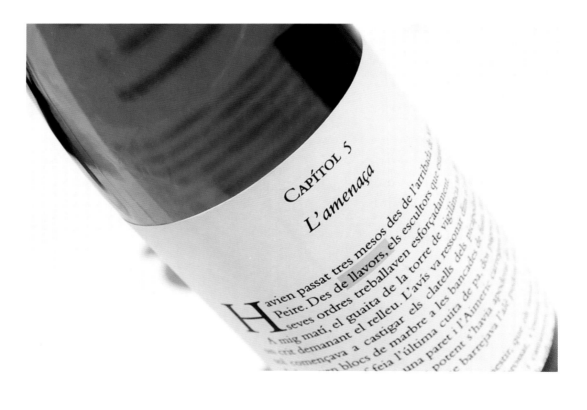

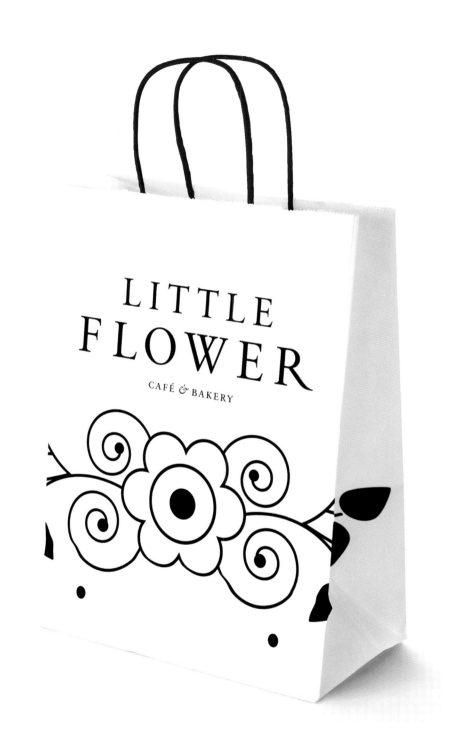

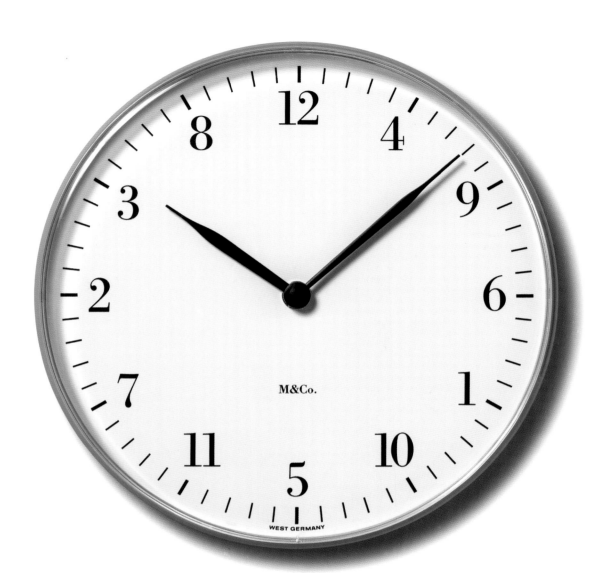

Bodoni

Designer: Giambattista Bodoni (1740–1813)

c. 1818: Parma, Italy

Modern Versions:

Monotype Bodoni, 1911

Bauer Bodoni, 1926

Bodoni 72, 1994

By the late eighteenth century, printing technologies, new ink formulas, and better paper provided the ability to print more delicate forms. Giambattista Bodoni designed Bodoni as a more geometric form, with straighter lines and more extreme variations between thick and thin parts of the letters. The forms follow the tenets of rationalism, a movement popular in the seventeenth and eighteenth centuries.

Bodoni has the classical forms of an old style serif typeface, but the sharper edges and straight lines give a more modern and fresh impression. Bodoni was a favorite of Massimo Vignelli, who limited his typographic options. He stated, "Out of thousands of typefaces, all we need are a few basic ones, and trash the rest."

SUGGESTIONS FOR SUCCESSFUL APPLICATION

➼ With more extreme differences between the thick and thin forms, Bodoni can create a "dazzle" effect. Increase leading to counteract this.

➼ Bodoni 72 is a more decorative version that is good for headlines. Minimize use with text and body copy.

➼ Bodoni does not have a set of alternative old style figures. As an option, classical typesetters often reduced the size of the numeral by one point.

APPLICATIONS

Guerlain Parfumeur packaging

Armani Exchange logo

Modern Family television program logo

SIMILAR

Filosofia

Didot

Walbaum

Modern

OPPOSITE

Askew Clock

M&Co. - 1989

Clock

Designed at Tibor Kalman's M&Co., the Askew Clock, with its mixed-up Bodoni numerals, was part of a series of clocks and watches. The promotion card for M&Co. Labs clocks describes the clock with the tagline, "Something's wrong with this one."

ABOVE
Design: Vignelli
Massimo Vignelli - 1992
Book
Massimo Vignelli worked with a limited
typographic palette, which included his
version of Bodoni. This version simplifies
the letterforms, with cleaner horizontal and
vertical strokes.

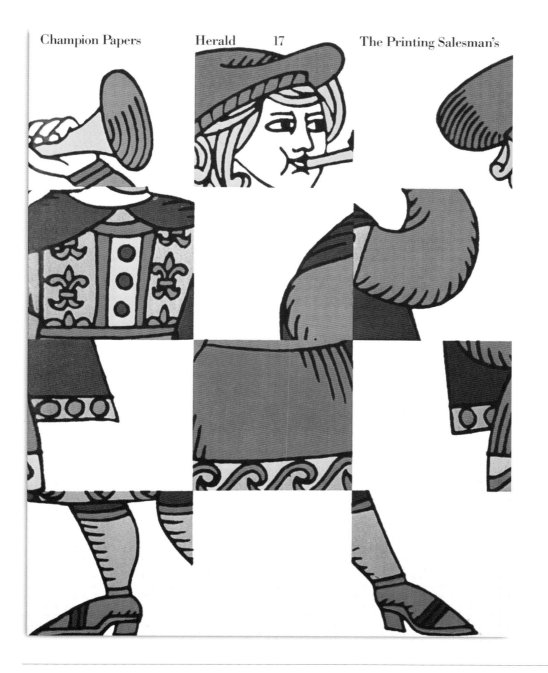

ABOVE
Champion Papers Herald 17
Louis Danziger - 1968
Publication
To communicate the idea of a herald and
printing, Danziger divides a traditional
"herald" image into twelve units, representing
different sheets of printed paper.

WILLIAM HAZLITT

ON

THE

PLEASURE

OF HATING

———

LOVE TURNS, WITH A LITTLE
INDULGENCE, TO INDIFFERENCE
OR DISGUST: HATRED ALONE
IS IMMORTAL

PENGUIN BOOKS

GREAT IDEAS

TRUMAN CAPOTE

The New York Public Library
Edna Barnes Solomon Room
Fifth Avenue and 42nd Street
December 2, 1987–March 19, 1988

On the Pleasure of Hating
David Pearson - 1992
Book
William Hazlitt published the short story *On the Pleasure of Hating* in 1821. It explores the idea of hating an object or other rather than ourselves. Pearson's use of Bodoni is clinical and direct.

Truman Capote
Sean Adams - 1987
Poster
The New York Public Library exhibited a collection of artifacts from the Truman Capote estate. The photograph is by Henri Cartier-Bresson (1947). Bodoni references Capote's first edition of *In Cold Blood*.

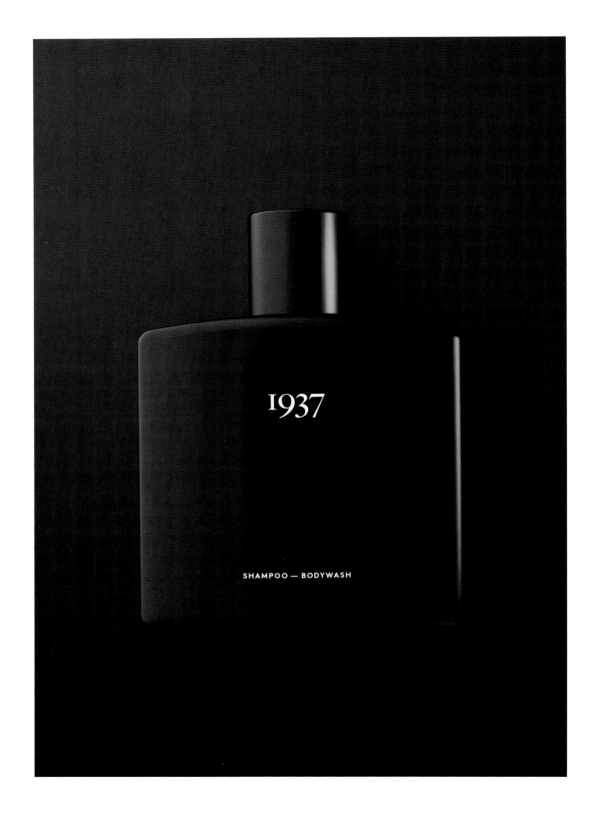

Caslon

Designer: William Caslon (1692–1766)

c. 1725: London, UK

Modern Versions:

Adobe Caslon, 1990

Caslon 540, 1902

ITC Caslon 224, 1982

William Caslon designed Caslon c. 1725, basing the typeface on seventeenth-century Dutch type drawings. Caslon is a further evolution of Bembo, with letterforms aligned less with hand-made calligraphic forms. The strokes have even contrast between the thick and thin weights and simpler curves. Throughout the eighteenth century, Caslon was the dominant typeface for text and book publishing. The first printed version of the United States Declaration of Independence was typeset in Caslon. The typeface fell out of favor during the nineteenth century but became the "go-to" typeface for much of the twentieth century. A maxim from mid-century art directors expresses its popularity: "You can't go wrong with Caslon."

Caslon 223 and 224—designed by Ed Benguiat of Lubalin, Smith, Carnase—have exaggerated weight differences and curves. They were popular in the 1960s and 1970s as a display typeface, based loosely on William Caslon's original version.

SUGGESTIONS FOR SUCCESSFUL APPLICATION

➻ If incorporating swash characters, use sparingly. Too many swashes are like too many French pastries: one or two are good; six will make one sick.

APPLICATIONS
U.S. Declaration of Independence
University of Virginia logo
Georgetown University logo
Surface magazine

SIMILAR
The Fell Types
Baskerville
Imprint

OPPOSITE
1937
Bold Scandinavia – 2017
Packaging
Bold Scandinavia designed a line of products for an iconic barbershop in Copenhagen named 1937—the date the Copenhagen Gutenberghus was rebuilt. The design communicates the shop's history and authenticity, with a modern attitude.

BELOW
Reales Ordenanzas Del Importante Cuerpo De La Minería De Nueva-España
Madrid – 1783
Title page
A book explaining the royal ordinances for the direction, regime, and government of the important body of mining in New Spain, and its real general court by order of his majesty.

OPPOSITE
Caslonian
Jean François Porchez – 2013
Typeface
Porchez demonstrates the refined forms and ligatures of his typeface, Caslonian, with a recreation of Herb Lubalin's cover for *fact:* magazine (1964).

FOLLOWING
Pictures
Sean Adams – 2017
Magazine
The typography is puropsefully spare with one typeface, Caslon, in only two sizes for the entire photography publication. The images here are by Herbert List (1951) and Carl Van Vechten (1935).

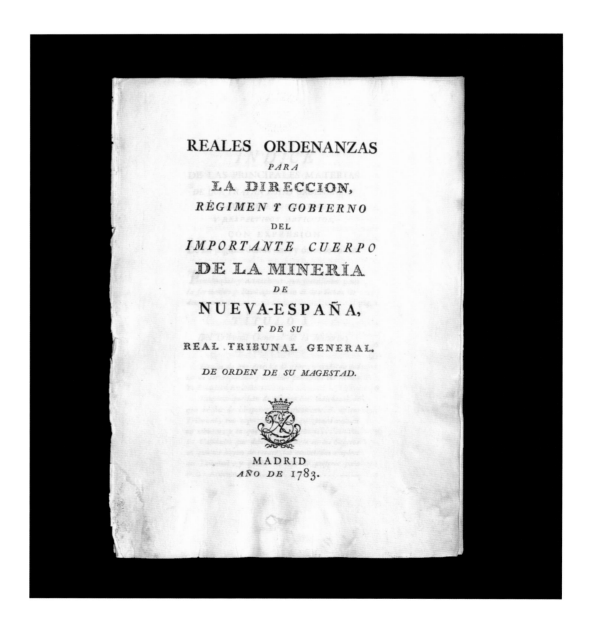

fact

VOLUME ONE, ISSUE SIX $1.25

CASLON

» TRANSITIONAL SERIF

Coca-Cola can cause tooth decay, headaches, acne, nephritis, nausea, delirium, heart disease, emotional disturbances, constipation, insomnia, indigestion, diarrhea & mutated offspring.

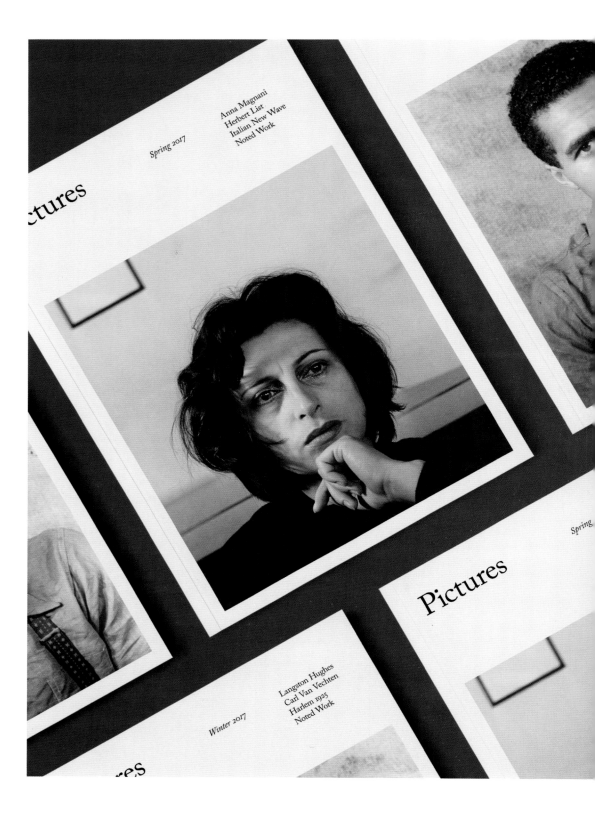

Spring 2017

Anna Magnani
Herbert List
Italian New Wave
Noted Work

Pictures

Spring

Winter 2017

Langston Hughes
Carl Van Vechten
Harlem 1925
Noted Work

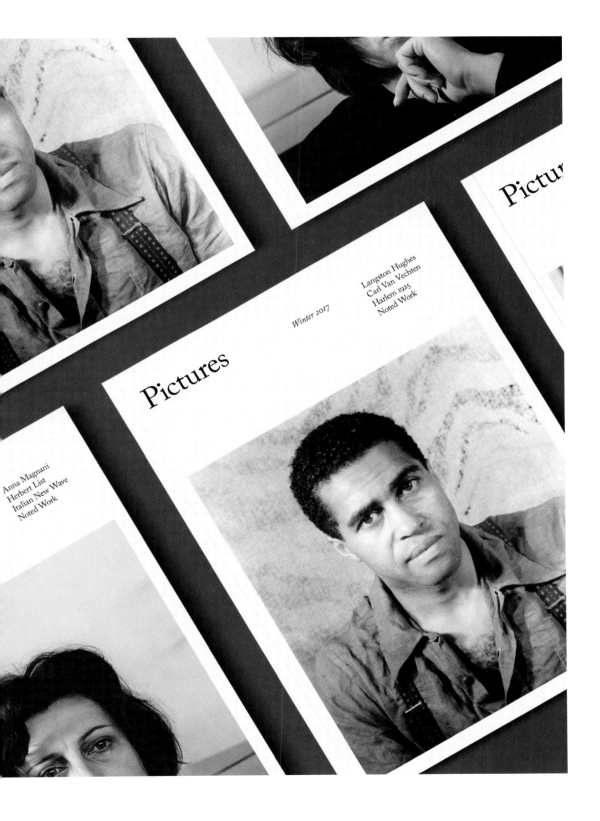

Pictures

Winter 2017

Langston Hughes
Carl Van Vechten
Harlem 1925
Noted Work

Pictures

Anna Magnani
Herbert List
Italian New Wave
Noted Work

Pictur

THE

HOLY BIBLE

Containing the Old and New
Testaments : Translated out
of the Original Tongues and
with the former Translations
diligently compared and re-
vised by His Majesty's special
Command

Appointed to be read in Churches

OXFORD
Printed at the University Press
1935

Centaur

Designer: Bruce Rogers (1870–1957)
1914: New York, New York, USA

Modern Versions:
Monotype Centaur, 1928

In 1914, the Metropolitan Museum of Art in New York commissioned Bruce Rogers to design a typeface for the book *The Centaur*. Rogers based the typeface on type designed by Nicolas Jenson in 1470. The original version had only capitals, but Rogers added a lowercase in 1915. With no italics, Frederic Warde designed an accompanying typeface, Arrighi, in 1929. This italic version was influenced by the calligraphic letterforms produced by Ludovico Vicentinio degli Arrighi in 1524—hence its name.

Centaur is sharp and delicate. It has a connotation of the high-end, luxury, and refinement. The calligraphic forms may also appear medieval or applicable to subjects such as antiquities or rare books. The *Game of Thrones* logo is related to Centaur and Trajan, which is also based on Jenson's Venetian forms.

SUGGESTIONS FOR SUCCESSFUL APPLICATION

➥ Centaur was designed for metal type on paper. The delicate strokes broadened because of the ink used and the pressure of printing. Digital versions maintain the same delicacy but may look anemic when printed with a laser printer or high-quality offset lithography. Use Centaur as the titling typeface but switch to Bembo for body copy and other small text.

APPLICATIONS
Oxford University Press Holy Bible
John Varvatos branding and logo
Penguin Classic book covers, 1946

SIMILAR
Cloister Old Style
Bembo
Dante
Adobe Jenson

OPPOSITE
The Oxford Lectern Bible
Bruce Rogers ~ 1935
Book
The Oxford Lectern Bible is considered Bruce Roger's masterpiece. Two hundred copies of the Bible were letterpress printed on hand-made paper. Rogers designed the book with his typeface Centaur, introducing a modified version for compact setting of text.

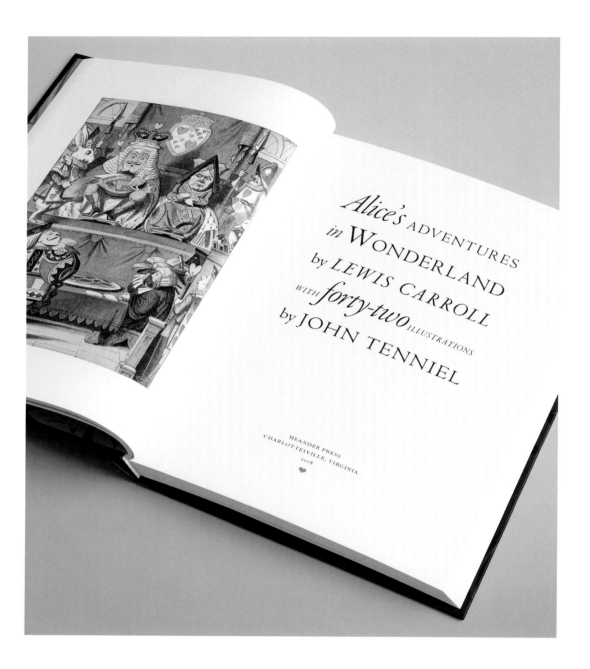

Alice's ADVENTURES
in WONDERLAND
by LEWIS CARROLL
WITH *forty-two* ILLUSTRATIONS
by JOHN TENNIEL

MEANDER PRESS
CHARLOTTESVILLE, VIRGINIA
2008

ABOVE
Alice's Adventures in Wonderland
Sean Adams - 2008
Book
Several variations of Centaur are applied
to the title page of this edition of *Alice's
Adventures* to communicate the multiple
changes she experiences in the plot.

OPPOSITE
***Schriftkunde, Schreibübungen und
Skizzieren***
Jan Tschichold - 1951
Book cover
After World War II, Tschichold reversed
his preference for asymmetrical typo-
graphy, focusing on symmetry and
classical typefaces.

E·R·WEISS SCHREIB DEM VERFASSER ÜBER DIESES BUCH: SEIEN SIE HERZLICH
BEDANKT FÜR DAS NEUE SCHRIFTBUCH · MAN KANN DAS NICHT BESSER MACHEN, IN JEDER BEZIEHUNG * STANLEY MORISON

Schrift
kunde
Schreib
übungen
und
Skizzieren

EIN LEHRBUCH DER SCHRIFT

VON JAN TSCHICHOLD

FÜR SETZER

GRAPHIKER UND FREUNDE

GUTER SCHRIFT

LAYOUT IS MOST PLEASINGLY WRITTEN AND PRINTED ·THE BOOK GAINS A GREAT DEAL TOO FROM YOUR OWN CALLIGRAPHY
SCHREIB: LIKE ALL YOUR PUBLICATIONS, YOUR NEW BOOK ON TYPOGRAPHY AND

CENTAUR

» OLD STYLE SERIF

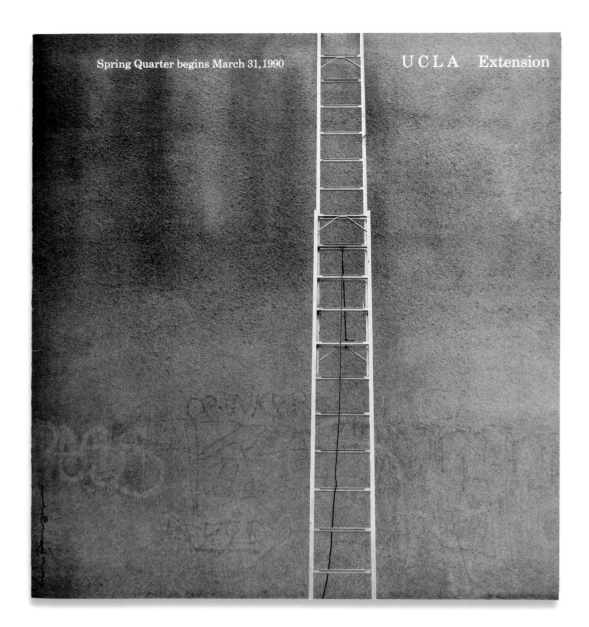

Spring Quarter begins March 31, 1990

U C L A Extension

Century

Designers:

Linn Boyd Benton (1844–1932)
Morris Fuller Benton (1872–1948)
1894: New York, New York, USA

Modern Versions:

Century Expanded, 1900
Century Old Style, 1906
Century Schoolbook, 1924

Linn Boyd Benton designed the first version of Century in 1894 for *Century* magazine. Theodore Low De Vinne, the publisher of *Century*, disliked the popular text typefaces of the late nineteenth century, which had become thinner and more delicate. De Vinne asked Benton to create a typeface that went against this: a sturdier and more legible face. Benton's son, Morris Fuller Benton, continued his work, designing Century Expanded in 1900. The popularity of the typeface spawned multiple variations from several type foundries.

Century is an extremely legible typeface. As such, it has been used on reading primers for decades, and the United States Supreme Court requires all briefs to be typeset in the Century family.

SUGGESTIONS FOR SUCCESSFUL APPLICATION

➥ Century Expanded is not expanded. It is slightly condensed and is the most legible face in the family for text.

➥ ITC Century has an enlarged x-height for use as a headline typeface rather than at smaller sizes.

APPLICATIONS
Prudential logo
Clinique Happy packaging
Dick and Jane book series

SIMILAR
Eames Century
Modern
Old Standard TT

OPPOSITE
UCLA Extension Spring Quarter
Louis Danziger – 1990
Publication
To communicate the concept of education, Danziger set his own extension ladder on the wall of his house. The extension ladder speaks to the client (UCLA Extension) and is a metaphor for the experience of education, as the student gains knowledge step by step. Century Expanded is the perfect choice with its relationship to reading primers.

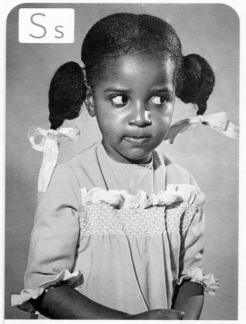

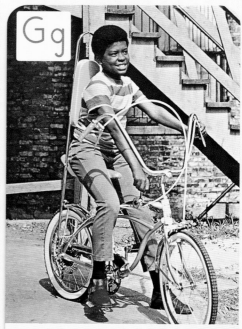

ABOVE
Black ABCs
Society for Visual Education - 1970
Flash cards
The flash cards depict people and situations particularly relevant to many city children, making the reading readiness program in Chicago city schools more meaningful.

OPPOSITE
U.S. Marines
Joseph Christian Leyendecker - 1917
Poster
For this World War I recruitment poster, Leyendecker hand-painted the Century headline. These posters communicated the adventure of the Marines to young men in small towns.

www.afropunk.com

afrotopia

MAY 2ND–3RD, 2018
EXPOSITION PARK
LOS ANGELES, CALIFORNIA

Cooper Black

Designer: Oswald Bruce Cooper
(1879–1940)
1921: Illinois, USA

Modern Versions:
Adobe Cooper Black, 2002
Linotype Cooper Black, 1921

Cooper Black has a close association with the 1970s; however, Oswald Cooper actually created the typeface in 1921. Cooper designed the Black weight after releasing a larger Cooper Old Style family of fonts. The forms are based on old style serif typefaces but are "fat" and soft. This type of letterform gained popularity between 1910 and 1920. Other designers worked with similar forms, such as Frederic Goudy and his typefaces Goudy Heavy Face and Pabst Extra Bold.

In the 1960s and 1970s, designers looking for alternatives to cold Swiss modernism and Helvetica looked back and revived Cooper Black. Its soft forms worked exceptionally well with phototypesetting, which allowed for extremely tight kerning. Both the counterculture movement and low-end DIY design adopted Cooper Black. By the end of the 1970s, the typeface was ubiquitous, but it again fell out of fashion as the New Wave movement gained momentum.

SUGGESTIONS FOR SUCCESSFUL APPLICATION
➤ Cooper Black will always communicate a friendly and casual tone. Avoid using it for severe or clinical information.
➤ The soft forms of Cooper Black work well with tight kerning and leading.

APPLICATIONS
Pet Sounds album cover
EasyJet logo
Napoleon Dynamite Vote for Pedro T-shirt

SIMILAR
Goudy Heavy Face
Oz
Windsor

OPPOSITE
Afropunk Festival
Yuma Naito - 2018
Poster
The Afropunk Festival is a music festival/human rights movement. It focuses on multiculturism, individuals, and positive energy in diverse communities with music, design, and art.

Fred S·Bertsch & Oswald Cooper ten years at Room 718 Athenaeum Building 59 E·Van Buren Street have moved across the hall to Room 703 and they have a new telephone number Harrison 5889 May 1914

ABOVE
Fred S. Bertsch & Oswald Cooper
Oswald Cooper - 1921
Moving announcement
The hand-drawn version of Cooper Black
on this moving announcement displays
the organic intent and Cooper Black's
connection to the Arts and Crafts movement.

OPPOSITE
The Smudge
Clay Hickson - 2017
Magazine
Following the examples of the alternative and
underground press of the 1960s and 1970s, *The
Smudge* offers a different perspective and voice
on current issues and events.

The SMUDGE

Just gonna do this until we figure something else out

TIME TO GET BACK TO WORK

COOPER BLACK

» OLD STYLE SERIF

41AD
NY62

Didot

Designer: Firmin Didot (1764–1836)
1784: Paris, France

Modern Versions:
CBS Didot, 1959
Linotype Didot, 1991
HTF Didot, 1991

Firmin Didot designed Didot in response to the improvements in printing and paper technologies in the eighteenth century. Faster-drying inks and smoother paper allowed for a typeface with extremely thin and thick strokes with high contrast. Didot has a clear relationship to Bodoni, with its sharp angles, lack of complex serif forms, and contrast. During the printing process, the thin strokes expanded and produced a delicate yet robust impression. The same letterforms suffer from a "dazzle" effect with digital or high-end offset printing. Without the added expansion, the strokes have too much contrast to be legible as a text typeface.

Vogue magazine adopted Didot for its cover logo in 1955. Other fashion magazines such as *Harper's Bazaar* soon followed. Didot now has a strong association with fashion and style.

SUGGESTIONS FOR SUCCESSFUL APPLICATION

➦ Adrian Frutiger's version, Linotype Didot, designed in 1991, is one of the most successful versions.

➦ HTF Didot is extremely flexible and has a large family with multiple variations for different font sizes.

APPLICATIONS
Vogue cover logo
CBS logo
Harper's Bazaar cover logo

SIMILAR
Bodoni
Didot Elder

OPPOSITE
41st Art Director's Annual
Robert M. Smith - 1962
Book cover
The cover for the Art Directors Club of New York annual is a pure expression of the refined forms of Didot. The contrasting heavy and hairline-thin strokes are elegantly presented at a large scale.

FOOD DESIGN & CATERING RÍO GUADALQUIVIR Nº 324 ORIENTE / COLONIA DEL VALLE SAN PEDRO GARZA GARCÍA NUEVO LEÓN COCINA +52 (81) 8344.2202 OFICINA +52 (81) 8378.6768 ALBERTOSENTIES.COM INFO@ALBERTOSENTIES.COM

ABOVE
Alberto Sentíes
Anagrama - 2016
Branding
Alberto Sentíes heads the catering company dedicated to honest experiences. The application of Didot communicates this with sophistication and elegance.

OPPOSITE
Irving Trust Company
Sauvard - 1952
Annual report cover
Letterpress printed in Deberny Peignot's Didot, on Arches white laid paper, this annual report cover communicates professionalism, honesty, and a clear vision.

IRVING TRUST COMPANY

One Wall Street, New York, N.Y.

Branch Offices

FIFTY-SEVENTH STREET AT MADISON AVENUE
FORTY-SECOND & FORTY-SIXTH STREETS AT PARK AVENUE
WOOLWORTH BUILDING • TWENTY-FIRST STREET AT FIFTH AVENUE
FIFTY-FIRST STREET AT ROCKEFELLER PLAZA
THIRTY-NINTH STREET AT MADISON AVENUE
EMPIRE STATE BUILDING

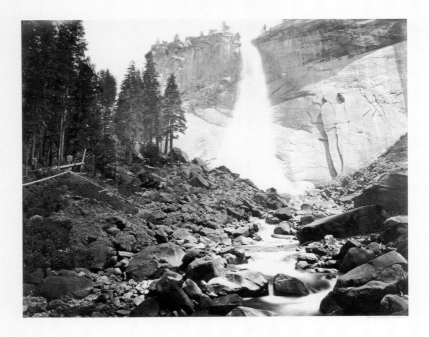

ABOVE
Eadweard Muybridge April/May 1981
Gail Taras ~ 1981
Poster
Known for his motion studies, Muybridge's image *Yowiye Falls, Mirror Lake* (1872), displays his skill as a landscape photographer. The Fraenkel Gallery is one of California's premiere photography galleries.

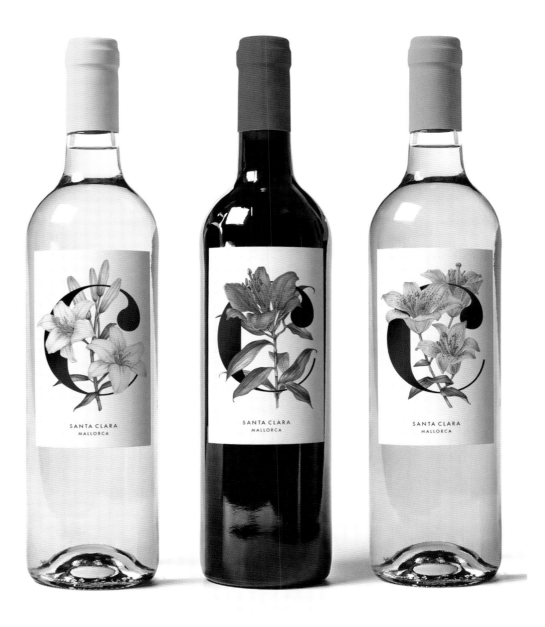

ABOVE
Santa Clara Wine Identity
Astrid Stavro, Pablo Martin: Atlas ~ 2012
Packaging
Botanical illustrations identify the contents of
each wine bottle through a connection to the
color. The images intertwine with the Didot
logo like a vine on a trellis.

Art Auction Brunch

Garamond

Designer: Claude Garamond
(c. 1480–1561)
c. 1532: Paris, France

Modern Versions:
Adobe Garamond, 1989
Garamont, 1925
ITC Garamond, 1975
Monotype Garamond, 1923

Claude Garamond is credited with the first version of Garamond, designed c. 1532. There is dispute over the actual provenance, as some claim present-day Garamond is based on the work of Jean Jannon's designs 60 years after Garmond's forms. The evolution of the typeface was based more on economic issues than aesthetic: the thinner strokes and larger counters using less ink and drying faster during the printing process.

Garamond is a classic typeface that communicates authority and academia. Employed historically as a book typeface, Garamond reads as "literature" without appearing overly decorative. As a common typeface, Garamond is unobtrusive. It doesn't call attention to itself, allowing the images or written content to be most prominent.

SUGGESTIONS FOR SUCCESSFUL APPLICATION

➤ Garamond Bold is a contemporary creation that should be avoided, as many versions lack the elegance of Garamond.

➤ As the italic version is optically smaller, set italics 1/2 point larger than roman type sizes to appear consistent.

➤ Old style figures should be used with upper- and lowercase letters. Aligning figures pair with all capitals.

APPLICATIONS
Harry Potter book series, U.S. edition
Apple Computer identity and advertising

SIMILAR
Granjon
Janson
Sabon

OPPOSITE
Art Auction Brunch
George Tscherny - 1970
Catalogue cover
Working with a fused metaphor of the art frame and an egg, Tscherny conveys the concept of brunch and art. The Garamond italic echoes the elaborate shapes in the frame.

Champion Calendar
Kit Hinrichs: Jonson, Pedersen,
Hinrichs & Shakery - 1983
Calendar
As a promotion to highlight Champion
Paper's product, Hinrichs designed a unique
horizontal calendar using ITC Garamond.

Collages, April/Mai 1962
Robert Motherwell ~ 1962
Poster
Designed for an exhibition of collages and
paintings at Galerie Der Spiegel in Cologne-
Deutz, the crisp forms of Garamond contrast
with the bold paint strokes.

Shakespeare's Globe Theatre
Graphic Thought Facility ~ 2003, 2004
Poster campaign
The contemporary photographs communicate
a modern tone. Janson, a seventeenth-
century typeface related to Garamond,
reinforces the classical and historic elements
of the content.

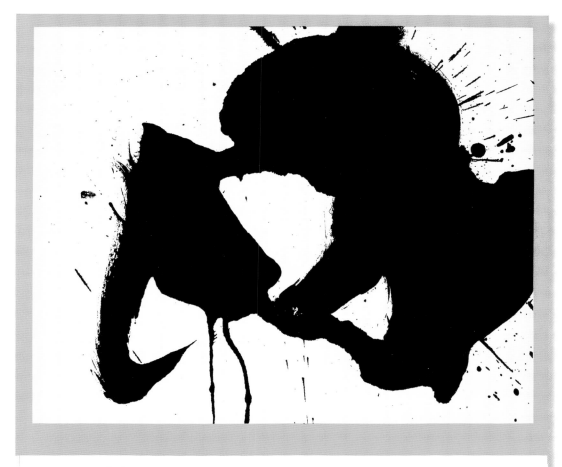

ROBERT
MOTHERWELL Collages · April/Mai 1962 · Galerie Der Spiegel · Köln · Richartzstraße 10 (am W.R. Museum)

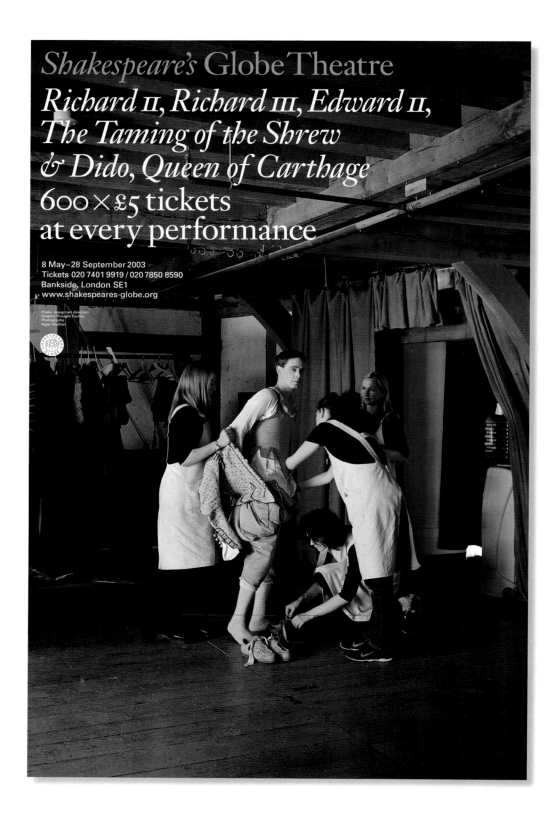

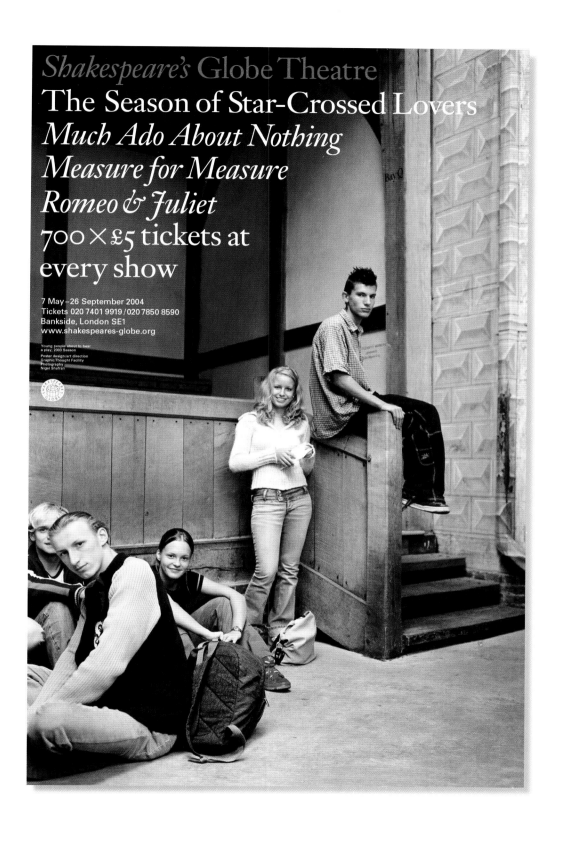

Shakespeare's Globe Theatre
The Season of Star-Crossed Lovers
Much Ado About Nothing
Measure for Measure
Romeo & Juliet
700 × £5 tickets at every show

7 May–26 September 2004
Tickets 020 7401 9919 / 020 7850 8590
Bankside, London SE1
www.shakespeares-globe.org

Young people about to hear
a play, 2003 Season
Poster design/art direction
Graphic Thought Facility
Photography
Nigel Shafran

GARAMOND

» OLD STYLE SERIF

>|American Paintings from The Metropolitan Museum of Art |<

Design: Louis Danziger

Los Angeles County Museum of Art Lytton Gallery June 3 - July 31, 1966

Perpetua

Designer: Eric Gill (1882–1940)

1925: Capel-y-ffin, Powys, Wales, UK

Modern Versions:

Adobe Perpetua, 2007

Monotype Perpetua, 2001

In 1925, Stanley Morison, the typographical advisor for Monotype, hired Eric Gill, a sculptor and engraver, to design a typeface that was not based on any historical model. He designed Perpetua as a crisp, sharp, and contemporary typeface, unconnected to calligraphic forms. Gill and Morison, both devoutly Catholic, based the name on the Christian martyr Vibia Perpetua. However, the pair failed in their goal of creating a new typeface to replace traditional historical types such as Garamond. Perpetua has a small x-height, thin strokes, and delicate serifs, and these attributes made the typeface difficult to work with in text. It was soon relegated to limited-edition books and display type.

The italic version of Perpetua has a troubled past. Morison and Gill attempted to take a more modern approach, designing a typeface with slanted roman letterforms. Unfortunately, Monotype rejected this design, deeming it "worthless." The final italic version incorporates some of the "slant" concept while adding cursive forms.

SUGGESTIONS FOR SUCCESSFUL APPLICATION

➤➤ As a delicate and fine typeface, Perpetua can appear anemic. The letterspacing and kerning should counteract some of the "lightness."

➤➤ Digital versions may not incorporate the best kerning automatically. This should be done manually.

APPLICATIONS
Barack Obama 2008 presidential campaign
Bacardi Rum packaging
The King's School, Canterbury logo

SIMILAR
Lutetia
Joanna
Spectrum
Capitolium

OPPOSITE
American Paintings from The Metropolitan Museum of Art
Louis Danziger - 1966
Catalogue
Using the fused metaphor of an American flag and paintbrush, Danziger communicates the subject matter simply and directly. The Perpetua title and supporting text stand back and don't compete with the concept.

*A*NNIVERSARIES
AND ACQUISITIONS

THE NEW YORK PUBLIC LIBRARY
EDNA BARNES SOLOMON ROOM
FIFTH AVENUE AND 42ND STREET
MAY 12–SEPTEMBER 17, 1988

NELSON'S
LETTERS
FROM THE LEEWARD ISLANDS
AND OTHER ORIGINAL DOCUMENTS
IN THE PUBLIC RECORD OFFICE AND
THE BRITISH MUSEUM: EDITED BY
GEOFFREY RAWSON WITH NOTES BY
PROFESSOR MICHAEL LEWIS AND
ENGRAVINGS BY GEOFFREY WALES

THE GOLDEN COCKEREL PRESS
1953

Anniversaries and Acquisitions
Sean Adams - 1988
Book cover
The exhibition of an eclectic variety of
materials acquired by the New York Public
Library is represented through multiple
treatments of the Perpetua headline and text.

*Nelson's Letters from the Leeward
Islands*
Christopher Sandford - 1953
Title page
The Perpetua text echoes the sharp forms of
the seahorse's tail and trident. The type size
decreases proportionally from the top to the
bottom of the page.

*The Travels & Sufferings of Father Jean
de Brébeuf*
Eric Gill and Robert Gibbings - 1938
Title page
The book details the French Roman Catholic
missionary's experiences with the Huron in
Quebec. Although an artistic masterpice, the
book was a sales failure.

THE TRAVELS
OF FATHERJEAN
AMONG The HURONS
CRIBED BY HIMSELF
ED FROM THE FRENCH

THE GOLDEN COCKEREL

&SUFFERINGS DE BRÉBEUF ✛ OF CANADA AS DES- EDITED &TRANSLAT- AND LATIN BY THEO- DORE BESTERMAN

PRESS MCMXXXXVIII

THE DESIGNER'S DICTIONARY OF TYPE

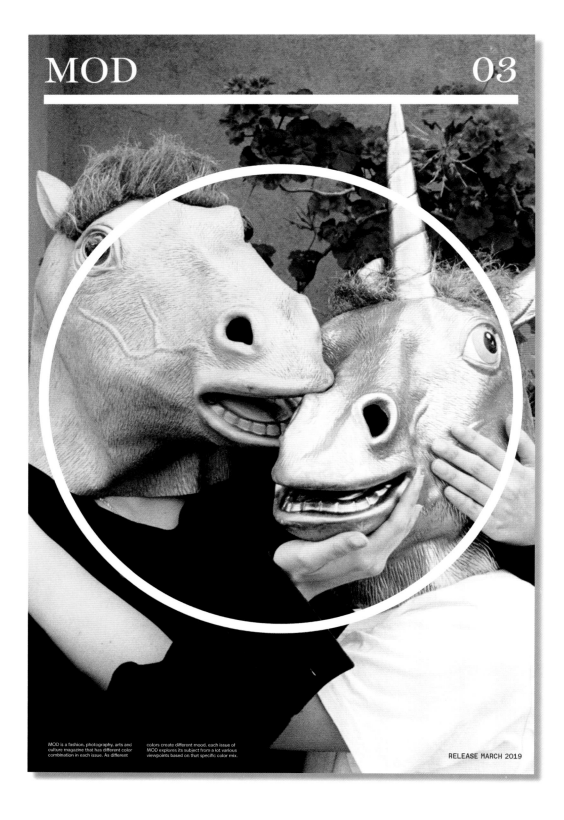

MOD is a fashion, photography, arts and culture magazine that has different color combination in each issue. As different colors create different mood, each issue of MOD explores its subject from a lot various viewpoints based on that specific color mix.

RELEASE MARCH 2019

Scotch Roman

Designers:

Richard Austin (1756–1832)

William Miller (d. 1830)

1812: Edinburgh, Scotland, UK

Modern Versions:

Linotype Scotch Roman, 1998

Monotype Scotch Roman, 2001

Scotch Roman is a typeface as well as a class of typefaces. It is based on designs by Richard Austin for William Miller's foundry in Edinbugh, Scotland (hence the name). Austin had previously designed Bell, and Scotch Roman contains many of the same traits. Scotch Roman typefaces have ball teardrops, sharp serifs, a vertical axis, and contrasting stroke weights. This family of typefaces was especially popular in the United States in the nineteenth century. The letterforms relate to Bodoni as a modern typeface, but have more curves and idiosyncrasies.

Matthew Carter's 1993 typeface Georgia, designed for Microsoft and inspired by Scotch Roman types, is one of the most internationally ubiquitous screen typefaces. Its name refers to a bizarre tabloid headline: "Alien Heads Found in Georgia."

SUGGESTIONS FOR SUCCESSFUL APPLICATION

➤ Scotch Roman's thick-and-thin contrast requires increased leading when set as text.

➤ Digital versions do not contain true small caps. This leads to capital letters that appear thicker and distract from the small caps.

APPLICATIONS

Bayerische Staatsoper branding

Saturdays Magazine

The Danish Shipowners' Association logo

SIMILAR

Bell

Walbaum

Miller

Modern No. 20

OPPOSITE

Mod Magazine

Irene Wiryanto - 2018

Magazine

Mod Magazine is a fashion, photography, arts, and culture magazine. A different color theme is applied to each issue of *Mod*, directing different editorial points of view.

EGYPT

AND

PALESTINE

Photographed and Described

BY

FRANCIS FRITH

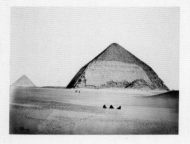

IN TWO VOLUMES

VOL. 1.

LONDON

JAMES S. VIRTUE, CITY ROAD AND IVY LANE

NEW YORK: 24 JOHN STREET

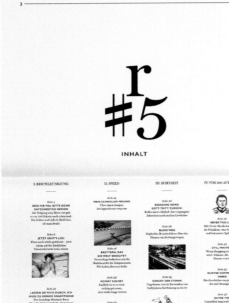

NUN MACHT MAL HINNE

Kein Zweifel, das Tempo hat angezogen. Die Technologisierung von Arbeitswelt und Freizeit lässt uns viel mehr Dinge erledigen als früher, und entsprechend sind die Ansprüche. Echtzeit heißt eines der neuen Zauberwörter, die eine Gleichzeitigkeit zum Fetisch macht, die ganz schön kräftezehrend ist. Denn tatsächlich nutzen wir die Zeit, die wir durch das Internet oder Smartphones gewinnen, nur selten zu Muße und Regeneration, sondern eher dazu, noch mehr zu tun.

Dabei bleibt oft die Qualität auf der Strecke. Viel Null-Kommunikation wird über SMS, Mails oder Handys betrieben, genauso augenfällig ist, dass Multitasking und Beschleunigung kaum noch Fokussierung zulassen, kaum noch Konzentration auf das Wesentliche – oder, bescheidener ausgedrückt: wenigstens mal auf eine Sache. Wir müssen also schleunigst über Geschwindigkeit reden.

Natürlich haben wir gerade als Ingenieure ein Faible für hohes Tempo, für das technisch Machbare, aber manchmal ist der Preis für immer höhere Taktzahlen zu hoch. Wir Brandschützer jedenfalls sind bestens vertraut mit der Notwendigkeit, die kommenden Dinge in aller Ruhe zu antizipieren und daraus tragfähige Lösungen abzuleiten. Mit dieser mittlerweile fünften Ausgabe unseres Magazins »Realitäten« (so schnell vergeht die Zeit) wollen wir Sie an den Gedanken, die uns bei der Arbeit leiten, und an den Entdeckungen, die uns begeistern, teilhaben lassen. Hoffentlich finden Sie einen Moment der Kontemplation.

Karsten Foth & Stefan Truthän

OPPOSITE
Egypt and Palestine: Francis Frith
James S. Virtue, Publisher · 1858–1859
Rare book
Photographing Middle Eastern landscapes and monuments established Francis Frith's reputation as one of the most important photographers of the nineteenth century.

ABOVE
Realitäten #5 contents
Jan Spading: ZMYK · 2015
Publication
Realitäten is published by the largest fire protection engineering firm in Germany for architects and builders. Spading's design is human and accessible.

FOLLOWING
Realitäten #5 interior
Jan Spading: ZMYK · 2015
Publication
The wry headline, "They Always Come Down," and the realistic documentary-style photo is a common approach with the magazine, typeset in a crisp and elegant Miller, a derivative of Scotch.

Runter kommen sie immer

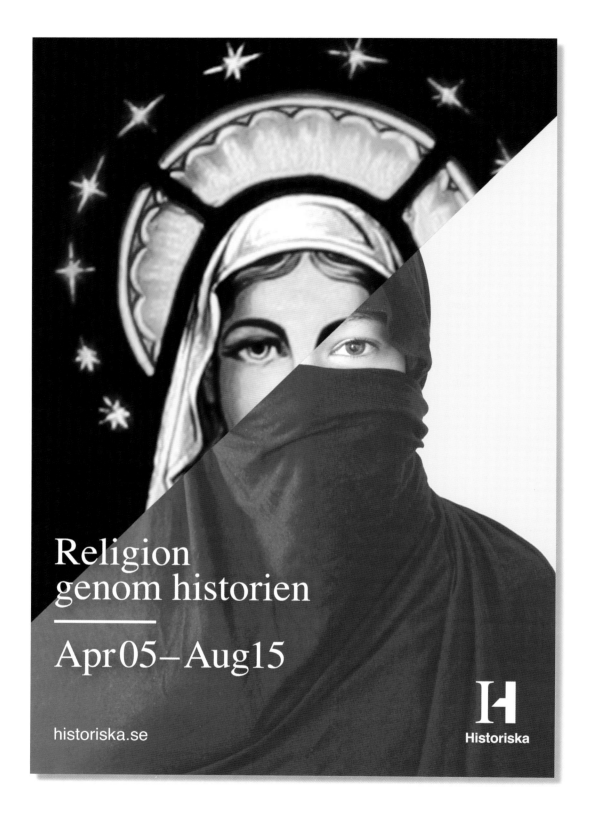

Religion
genom historien

Apr05–Aug15

historiska.se

Historiska

Times New Roman

Designers:
Stanley Morison (1889–1967)
Victor Lardent (1905–1968)
1931: London, UK

Modern Versions:
Adobe Times LT, 2007
Linotype Times Roman, 1932
Times Europa, 1972

After working with Eric Gill on Perpetua, Stanley Morison wrote an article criticizing *The Times of London* for bad printing and poor typography. In response, in 1931 *The Times* commissioned Morison to design a new typeface suited to newspaper printing and inexpensive paper. For a time, Morison looked at Perpetua as a possible starting point, but he soon turned to Plantin, making refinements for legibility at small sizes and a tighter character width. He collaborated with Victor Lardent, a lettering artist in *The Times*' advertising department, and created Times Roman. Previously, *The Times* was typeset in Times Old Roman, so Morison named his version Times New Roman.

By 1972, paper and printing technologies had improved and *The Times* commissioned a new version of the typeface. Walter Tracy designed a more robust version, Times Europa. As a typeface included with most operating systems, computers, and printers, Times New Roman has become the standard office typeface for almost any usage.

SUGGESTIONS FOR SUCCESSFUL APPLICATION

➤➤ As a ubiquitous typeface, Times New Roman, like Helvetica, can appear generic, unemotional, and default. It should be used purposefully and dramatically to avoid the appearance of an issue downloading other fonts.

APPLICATIONS
The Times of London
Return of the Jedi poster and logo
NASA corporate standards

SIMILAR
Plantin
Perpetua
Georgia
Nimbus Roman

OPPOSITE
Historiska
Bold Scandinavia - 2012
Identity and poster series
Bold chose Helvetica and Times Roman as the two typefaces for the identity of the Swedish History Museum. Both typefaces are unobtrusive, allowing the logo and the content of the museum to be the most prominent elements.

Auf einem Bein kann man nicht stehen

Vortragsreihe mit GestalterInnen, die andere Dinge auch gut machen

A bird never flew on one wing

A series of talks by designers who do other things as well

Sar a de Bo ndt

Grafikdesignerin und Verlegerin, Editorin

Graphic Designer and Publisher, Editor

**Dienstag
20. Nov 2012, 19:00**

Fachbereich Gestaltung
Hochschule Darmstadt

**Tuesday
20. Nov 2012, 19:00**

Faculty of Design
Hochschule Darmstadt

*

Andere Vorträge in dieser Reihe
Other talks within this series

Christoph Keller, 22. Mai 2012, 18:00
Verleger, Buchgestalter, Ausstellungsmacher und Edelobstschnapsbrenner
Editor, Book Designer, Curator and Choice Fruit Distiller

Kai von Rabenau, 5. Juni 2012, 19:00
Fotograf, Grafikdesigner und Verleger, Editor, Label-Betreiber
Photographer, Graphic Designer and Publisher, Editor, Label-Owner

Halbfünf-Vortragsreihe
Fachbereich Gestaltung & Verein der Freundinnen und
Freunde des Fachbereiches Gestaltung e.V.
Hochschule Darmstadt
Kurator 2012: Prof. Frank Philippin
Olbrichweg 10
D-64287 Darmstadt

h_da | fb g
Verein der Freundinnen und Freunde des
Fachbereiches Gestaltung e.V.

*

frotscher

OPPOSITE
A bird never flew on one wing
Billy Kiosoglou, Frank Philippin:
Brighten the Corners - 2012
Poster series
For a lecture series at the Hochschule
Darmstadt, the saying "a bird never flew
on one wing," is applied to split the design,
elegantly managing the bilingual text.

BELOW
President Ford '76
Unknown - 1976
Poster
For the 1976 United States presidential
campaign, President Gerald Ford's materials
were set in Times Roman. Its connection to
plain, honest information mirrored Ford's
no-nonsense approach.

FOLLOWING
Raffinerie
Raffinerie - 2016
Website
The homepage for the website
unapologetically incorporates aggressive,
large-scale text in Times Roman. The "non-
design" of the typography interacts with the
colorful and stylized imagery and shapes.

President Ford '76

The President Ford Committee, Howard H. Callaway, Chairman, Robert Mosbacher, National Finance Chairman, Robert C. Moot, Treasurer. A copy of our Report is filed with the Federal Election Commission and is available for purchase from the Federal Election Commission, Washington, D.C. 20463.

TIMES NEW ROMAN » TRANSITIONAL SERIF

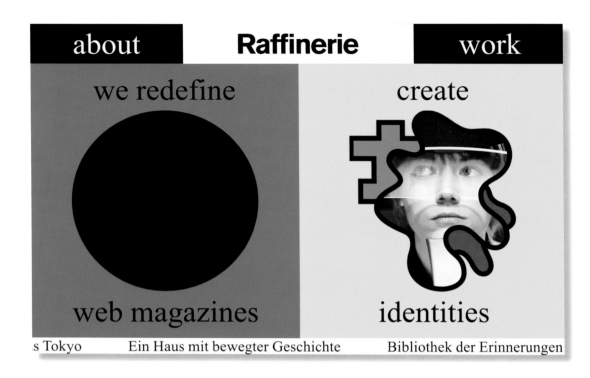

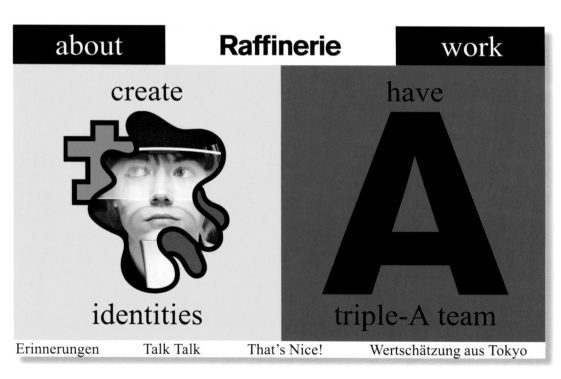

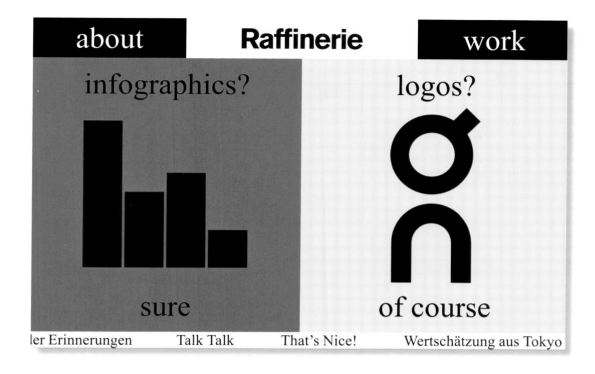

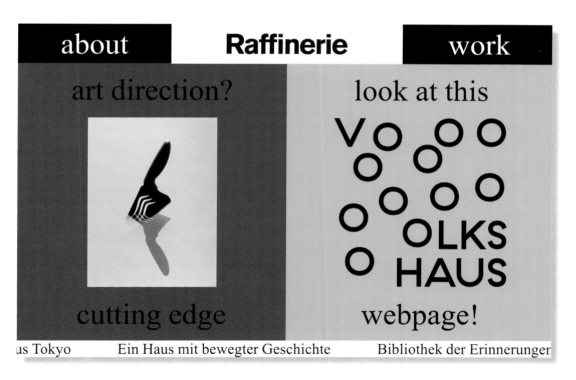

MONOTYPE BENBO

ABCDEFGHIJKLMNOPQRSTUVWXYZ
abcdefghijklmnopqrstvwxyz
1234567890&?$£

CHARACTERISTICS FOR IDENTIFICATION

flat apex large counter square terminal flat ear

ARQGag

square serif extended tail swash tail no attached spur

MONOTYPE BASKERVILLE

ABCDEFGHIJKLMNOPQRSTUVWXYZ
abcdefghijklmnopqrstvwxyz
1234567890&?$£

CHARACTERISTICS FOR IDENTIFICATION

square apex straight stem tall spur rounded terminal rounded ear

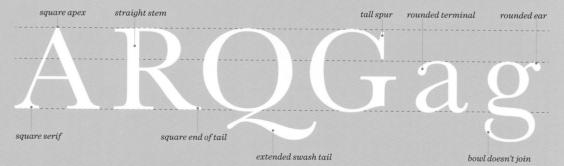

square serif square end of tail extended swash tail bowl doesn't join

MONOTYPE BODONI

ABCDEFGHIJKLMNOPQRSTUVWXYZ
abcdefghijklmnopqrstvwxyz
1234567890&?$£

CHARACTERISTICS FOR IDENTIFICATION

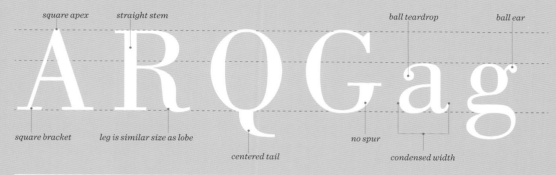

square apex straight stem ball teardrop ball ear

square bracket leg is similar size as lobe no spur

centered tail condensed width

CASLON 540

ABCDEFGHIJKLMNOPQRSTUVWXYZ
abcdefghijklmnopqrstvwxyz
1234567890&?$£

CHARACTERISTICS FOR IDENTIFICATION

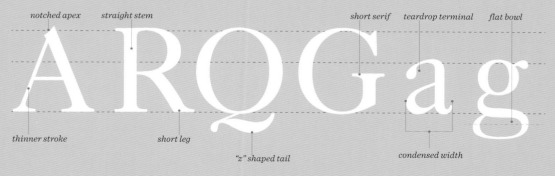

notched apex straight stem short serif teardrop terminal flat bowl

thinner stroke short leg

"z" shaped tail condensed width

Specimen

82

MONOTYPE CENTAUR

ABCDEFGHIJKLMNOPQRSTUVWXYZ
abcdefghijklmnopqrstvwxyz
1234567890&?$£

CHARACTERISTICS FOR IDENTIFICATION

slightly square apex curved stem square terminal calligraphic link

ARQGag

cupped serif short leg prominent left serif
 shorter tail

CENTURY EXPANDED

ABCDEFGHIJKLMNOPQRSTUVWXYZ
abcdefghijklmnopqrstvwxyz
1234567890&?$£

CHARACTERISTICS FOR IDENTIFICATION

flat apex wide lobe open counter tall spur ball teardrop rounded ear

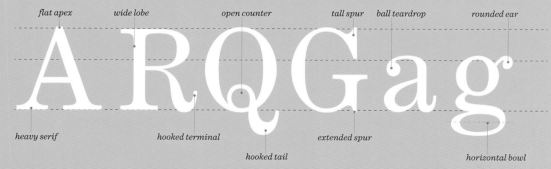

ARQGag

heavy serif hooked terminal extended spur
 hooked tail horizontal bowl

COOPER BLACK

ABCDEFGHIJKLMNOPQRSTUVWXYZ
abcdefghijklmnopqrstvwxyz
1234567890&?$£

CHARACTERISTICS FOR IDENTIFICATION

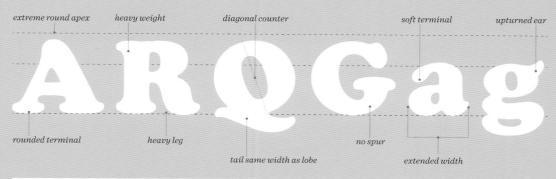

extreme round apex *heavy weight* *diagonal counter* *soft terminal* *upturned ear*

rounded terminal *heavy leg* *no spur*

tail same width as lobe *extended width*

HTF DIDOT

ABCDEFGHIJKLMNOPQRSTUVWXYZ
abcdefghijklmnopqrstvwxyz
1234567890&?$£

CHARACTERISTICS FOR IDENTIFICATION

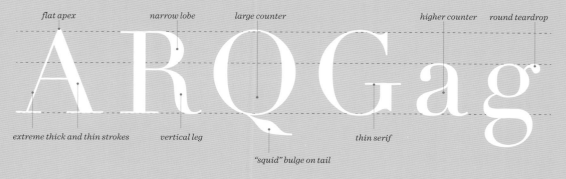

flat apex *narrow lobe* *large counter* *higher counter* *round teardrop*

extreme thick and thin strokes *vertical leg* *thin serif*

"squid" bulge on tail

ADOBE GARAMOND

ABCDEFGHIJKLMNOPQRSTUVWXYZ
abcdefghijklmnopqrstvwxyz
1234567890&?$£

CHARACTERISTICS FOR IDENTIFICATION

pointed apex small counter square terminal calligraphic link

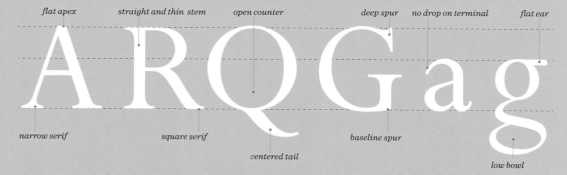

cupped serif short leg prominent spur lower bowl

extended tail from center

MONOTYPE PERPETUA

ABCDEFGHIJKLMNOPQRSTUVWXYZ
abcdefghijklmnopqrstvwxyz
1234567890&?$£

CHARACTERISTICS FOR IDENTIFICATION

flat apex straight and thin stem open counter deep spur no drop on terminal flat ear

ARQGag

narrow serif square serif baseline spur

centered tail

low bowl

Specimen

MONOTYPE SCOTCH ROMAN

ABCDEFGHIJKLMNOPQRSTUVWXYZ
abcdefghijklmnopqrstvwxyz
1234567890&?$£

CHARACTERISTICS FOR IDENTIFICATION

flat apex · heavy weight · open counter · teardrop terminal · teardrop ear

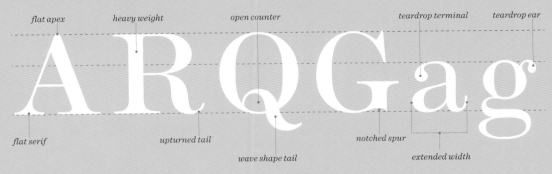

flat serif · upturned tail · wave shape tail · notched spur · extended width

MONOTYPE TIMES NEW ROMAN

ABCDEFGHIJKLMNOPQRSTUVWXYZ
abcdefghijklmnopqrstvwxyz
1234567890&?$£

CHARACTERISTICS FOR IDENTIFICATION

similar thick and thin strokes · narrow lobe · vertical stress · diagonal spur · horizontal ear

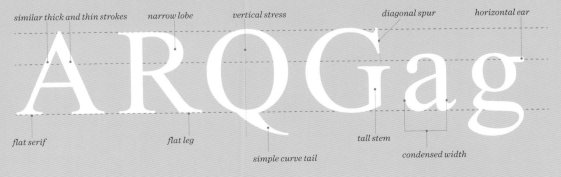

flat serif · flat leg · simple curve tail · tall stem · condensed width

Sans Serif

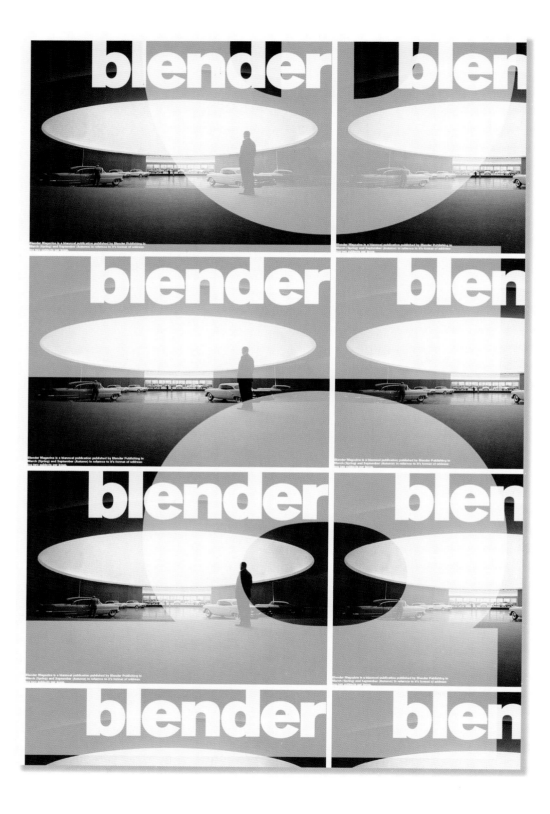

Akzidenz Grotesk

Designers:

Ferdinand Theinhardt (1820–1906)

Günter Gerhard Lange (1921–2008)

c. 1898: Berlin, Germany

Modern Versions:

Berthold Akzidenz Grotesk, 2001

Berthold Akzidenz Grotesk Next, 2006

In the late nineteenth century, the Berthold Type Foundry of Berlin released Akzidenz Grotesk. Its provenance is complex, but Ferdinand Theinhardt and Günter Gerhard Lange were clearly two of its originators. Unlike many serif typefaces of the same period, Akzidenz Grotesk was intended for commercial and industrial usage. Its sans serif forms were part of the tradition of nineteenth-century "grotesques." These were popular for trade publications, manuals, sales materials, tickets, and other commercial applications. By the art-moderne obsessed 1930s, geometric sans serif typefaces such as Futura had replaced Akzidenz Grotesk.

It was in the 1950s and 1960s that graphic designers rediscovered the typeface. The simple and neutral letterforms met the needs of work influenced by the Swiss modernists, or the International Style. In 1957, the Haas Foundry released Helvetica, and Deberny & Peignot released Univers. By the late 1960s, both of these had eclipsed Akzidenz Grotesk.

SUGGESTIONS FOR SUCCESSFUL APPLICATION

➤ Akzidenz Grotesk's weights and styles are too varied to read as a unified family. Use one weight overall, changing only the point size for hierarchy.

➤ Akzidenz Grotesk Next (2006) is the most successful iteration, refining forms and resolving consistency issues.

AKZIDENZ GROTESK

» GROTESQUE SANS SERIF

APPLICATIONS

New York Subway signage (modified)

American Red Cross logo

Josef Müller-Brockmann posters

SIMILAR

Venus

Edel-Grotesk

Helvetica

Theinhardt

OPPOSITE

Blender

Paul Knipper - 2017

Poster

Knipper designed the promotional poster for the first issue of *Blender* magazine, highlighting the article "Eero Saarinen's Michigan." The magazine is a biannual publication focused on the "blending" of two contrasting topics from the world of design and architecture.

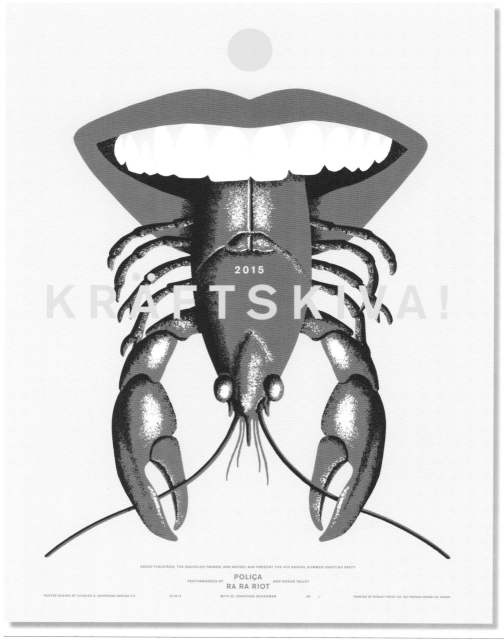

Kräftskiva!
Charles Spencer Anderson ~ 2012
Poster
Kräftskiva is Swedish for "crayfish party,"
a Nordic eating and drinking tradition.
Anderson's poster promoted the Bachelor
Farmer and Marvel Bar's *kräftskiva* event.

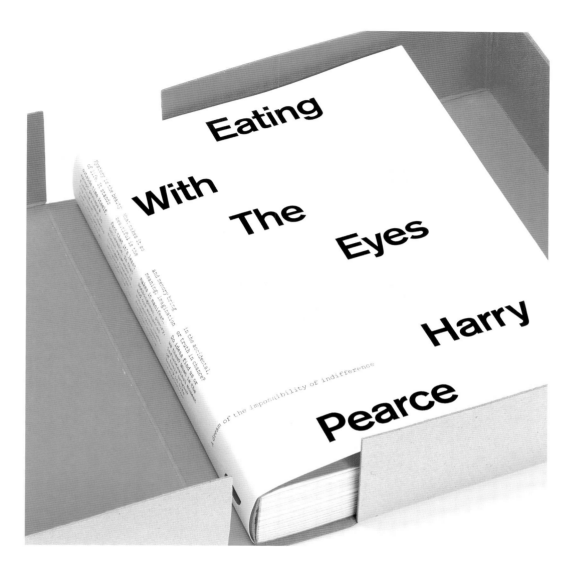

The book cover reads:

Eating
With
The
Eyes
Harry
Pearce

a stream of the impossibility of indifference

ABOVE
Eating With the Eyes
Harry Pearce ~ 2012
Book cover
This Unit Editions book is a photographic record of Pearce's accidental events. As Pearce explains, "I've come to realise that there are no true accidents, only ideas trying to find us."

FOLLOWING LEFT
Swissted, Agent Orange at Goodies Nightclub
Mike Joyce: Stereotype Design ~ 2016
Poster
Mike Joyce applies a technique of over-printing the Akzidenz Grotesk type, referring to classic mid-century Swiss poster design.

FOLLOWING RIGHT
Swissted, Gang of Four at American Indian Center
Mike Joyce: Stereotype Design ~ 2013
Poster
Joyce combines his appreciation for Swiss design with music for a series of posters. Each maintains the rigors of modernist typography applied to contemporary music.

with special guests
janes addiction
& electric cool aide

sunday / march 29 1987
18 and over with id
first band starts at 8 pm

goodies nightclub
1641 placentia avenue
fullerton, california

agent orange

thursday
may 22 1980
$6.50

with
special guests
b-people

two shows
8:00 & 11:00 pm

american indian center
225 valencia street
san francisco, california

gang of four

Nut Tree Store

SAN FRANCISCO

Avant Garde

Designers:
Herb Lubalin (1918–1981),
Tom Carnase (b. 1939)
1970: New York, New York, USA

Modern Versions:
ITC Avant Garde, 1970

In 1968, the publisher Ralph Ginzburg commissioned Herb Lubalin to design his controversial new magazine, *Avant Garde*. Lubalin and his partner, Tom Carnase, rejected the cold Swiss modernism of Helvetica and Univers. They designed typographic forms that were eccentric, appropriated elements from the Victorian and Art Deco eras, and utilized phototypesetting in groundbreaking ways. Avant Garde was initially designed for the logo of the magazine, but many designers requested a typeface version too.

Lubalin and Carnase worked with perfect round geometry, straight lines, and extreme weights. Without the limitation of metal type's inability to kern too tightly or overlap, Lubalin designed a large group of ligatures that merged letters together.

SUGGESTIONS FOR SUCCESSFUL APPLICATION

➤ Avant Garde is better suited as a headline typeface. It is difficult to read at small sizes due to the extreme geometric perfection.

➤ Initially, the typeface was typeset using the term "TNT," tight, not touching. This works.

➤ The numeral "0" is not a perfect circle. For a dramatic effect, replace it with the letter "O."

APPLICATIONS
Dolce & Gabbana logo
Calvin Klein Jeans branding
Adidas logo
Google logo

SIMILAR
Gotham
Futura

OPPOSITE
Nut Tree Store
Possibly Don Birrell ~ 1973
Shopping bag
The Nut Tree was a roadside development east of San Francisco, with a restaurant, store, bakery, railroad, and small airport. The graphic system was surprisingly sophisticated, with contemporary design.

With analog photography, amateur photo-
graphers received an envelope of negatives.
The Technicolor logo in Avant Garde is set
against a rainbow of vibrant tones, promoting
rich-color photograhic prints.

Here, Avant-Garde is placed on a color
known as 'water of the Nile'. These
reference the series' original design adding a
sophistated typography-based solution.

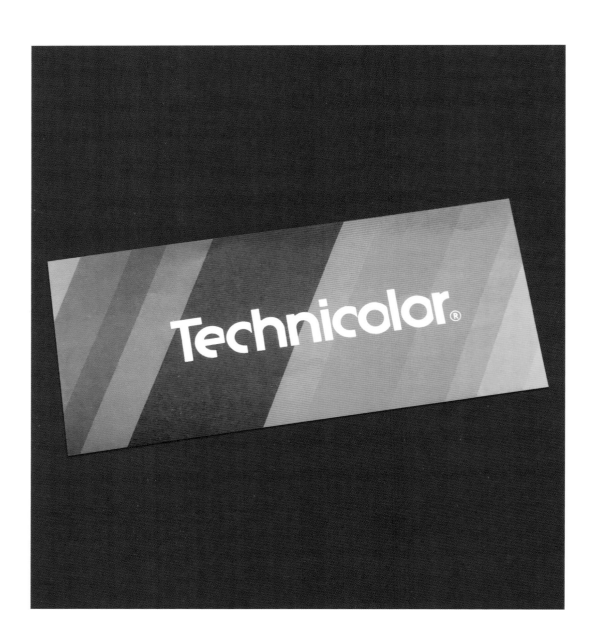

PENGUIN MODERN : 29

SUSAN
SONTAG

NOTES
ON
'CAMP'

PENGUIN MODERN : 23

AUDRE
LORDE

THE MASTER'S
TOOLS
WILL NEVER
DISMANTLE
THE MASTER'S
HOUSE

PENGUIN MODERN : 25

WILLIAM S.
BURROUGHS

THE
FINGER

PENGUIN MODERN : 40

WILLIAM
CARLOS
WILLIAMS

DEATH THE
BARBER

T&C
™

DON'T FLIP OUT JACK!

FLAP JACKS

MIX

——— CLASSIC ———

VANILLA BUTTERMILK

MADE IN
·AMERICA·

Restaurant quality flapjacks in a jiffy! Visit the pancake house from your kitchen with our easy to make buttermilk and vanilla pancake mix. Flapjacks aren't just for weekends anymore!

NET WT. 20 OZ (567g)

TASTE & CO.™
HONEST INGREDIENTS
AUTHENTICALLY CRAFTED

Avenir

Designer: Adrian Frutiger (1928–2015)
1988: Paris, France

Modern Versions:
Avenir Next, 2004
Linotype Avenir, 1988

In designing Futura in 1927, Paul Renner, adhering to Bauhaus mathematical purity, chose geometry over legibility, to create a typeface that is almost purely geometric. Sixty years after the introduction of Futura, Adrian Frutiger designed Avenir to correct and refine Futura's geometric approach. Frutiger's Avenir ("future" in French) maintains the spirit of simple geometric forms but takes liberties with letters to add warmth and legibility. The lowercase "a," for example, is a two-story letter, rather than the Futura "a," which is one bowl. Ascenders are shorter, allowing for tighter leading and a more cohesive appearance.

SUGGESTIONS FOR SUCCESSFUL APPLICATION

➤➤ Avenir is a good substitute for Futura. The two-story "a" and other modifications make it easier to read than Futura, with its geometric uniformity.

➤➤ Avenir is lighter than Futura and Gotham. Avenir Black is similar in weight to Futura Bold.

APPLICATIONS
Snapchat corporate typeface
City of Amsterdam branding

SIMILAR
Futura
Neuzeit Grotesk
Metro
Gotham
Verlag

OPPOSITE
Flap Jacks
Ellen Bruss, Rose Chenoweth, Ken Garcia: Ellen Brus Design - 2017
Packaging
Taste & Company's flapjack mix uses Avenir, a black-and-white illustration, and folksy language to convey a homespun American attitude with a touch of nostalgia.

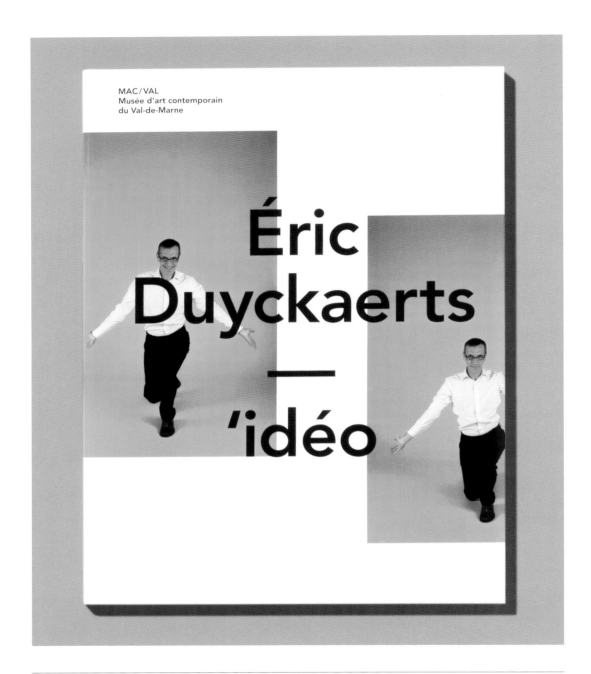

ABOVE AND OPPOSITE
'idéo, Éric Duyckaerts
Spassky Fischer - 2011
Publication
This is the monograph for the first major
exhibition in a French institution devoted
to Éric Duyckaerts. His work explores the
combining of knowledge and absurdity.

AVENIR

» GEOMETRIC SANS SERIF

Marie Muracciole

international variety shows.[18] Eric Duyckaerts is careful with words. He executes acrobatic figures of language and logical apropos before his audience: he puts the absurd into practice. The verbal choreography that storms from it, albeit immaterial, has an effect that goes past the programme it enunciates. Sometimes astounding, evicted by 'bursts' of laughter, it develops a movement that gives rise to another summons, which is inner and immediate: the poetic emotion.

Duyckaerts brings out this inner event and makes it appear in his speech as a short parable that could very well be an event by George Brecht: 'There's this guy, he's having tea and biscuits, well ... some kind of cake. So he dips it into the tea and brings it to his mouth and: it all comes back.'[19] Saying that, Duyckaerts opens his arms as if to receive 'all (that is) coming back to him'. His face lights up, his features display wholeness. Many forms of emotion are expressed through the parable of the little madeleine cake and involuntary memory. The violent emotion described by Marcel Proust that put him in touch with himself. And the emotion we have found by reading his text, since he has enabled us to name and ponder similar experiences we have had: an unexpected chance meeting with ourselves.

In the flow of small talk, rarely do we experience the brutal return of it 'all coming back' which does not come from words, but which words help us decipher. To survey the body of knowledge and to go through the motives of knowledge do not assure any

19 — 'There are those who would commit mayhem – not murder, perhaps, but mayhem – for the sake of a rhyme' recall a line from a song
'Fair Naples sleeping, v vigil keeping.'
Cognitive content to the words'
in Willard V. Quine, Quiddities: An Intermittently Philosophical Dictionary, Harvard University Press, 1987, p. 20.
20 — Mémoire, 2011

You get it?

retation of equivalence to such an abrupt summons on the inner stage, that rare and prodigious coincidence with oneself that comes from the outside. However, an epiphany always requires words and their floating ways to inscribe itself in our existence. This is what art is here for. And we mustn't forget it.

'Obviously, it goes a long long long way back.'[21]

— Marie Muracciole is an art critic and curator. Her recent publications include 'Tomorrow never knows,' Peter Rüehr (20/27, no. 5, M19) and Awrt ('Post ou De la survie de l'espece' (Avant/Post, Bernard Piffaretti, Epileptic, 2011). Currently busy on a book of Allan Sekula's writings (Beaux-arts de Paris), she is the curator of 'Riffs, Yto Barrada' at the Guggenheim Berlin (catalogue published by Hatje Cantz) and has written an essay on the artist to be published by JRP|Ringier.

21 — Détachement (Xu Xü), 2011.

24

25

Joseph Mouton

Catalogie

Catalogie

Essai d'oniro-critique

Nous courons en montagne. Les épreuves de course en montagne sont particulièrement exigeantes, parce qu'à l'endurance propre au coureur de fond, il faut ajouter des qualités de grimpeur (pensons par analogie aux spécialistes de la montagne que furent Richard Virenque ou feu Marco Pantani pour le cyclisme (récent). Nous courons sur les flancs d'une montagne du genre Pain de Sucre, ce qui signifie que nous affrontons presque sans répit des pentes très raides; mais, alors que nous abordons un plat descendant, je me fais réflexion que la montagne sur laquelle nous courons bien plutôt sur une idée de montagne, quand nos foulées enjambent concrètement des marches d'escalier ou frappent le béton nu des ponts. Je vois par exemple le premier coureur accélérer devant moi le mouvement alternatif de ses coudes dans la déclivité de la passerelle qui enjambe un précipice et l'éclat mat de la chaussée qui fuit devant sa silhouette trapue et solide, puis les obliques montantes des rampes qui nous attendent de l'autre côté. Moi qui ne suis pas du tout spécialiste des courses de montagne, me voici en tout cas en quatrième position et suivant parfaitement le train des premiers – chose stupéfiante si l'on y réfléchit! Pour revenir à la montagne, disons que sa grandeur sauvage demeure certainement en fond de tableau; j'imagine la profondeur d'un cirque sur quoi se découperait le tournant du chemin car, tout à ma course à vrai dire, je n'ai pas le loisir de regarder autour de moi. Mais, comme si la pensée de l'exploit prodigieux que je suis en train d'accomplir m'avait donné des ailes, s'était muée en une accélération effective de mon allure, je double le numéro trois et le numéro deux dans la montée des rampes que j'ai dites, je cours maintenant dans la foulée

du numéro un ! C'est un homme sensiblement plus petit que moi, vêtu d'un ensemble de sport taillé dans une étoffe soyeuse ou très élimée, d'un gris indéfinissable (peut-être évoquais-je alors à mon insu le personnage de Barnabas, dont Kafka écrit dans Le Château qu'« il était presque vêtu de blanc »); qui garde un rythme égal dans les montées les plus rudes et ne se retourne jamais vers moi, je suis là haletant ses cheveux bruns coupés court à la nuque. Nous parvenons ainsi au sommet, où s'achève la course. Or voici « l'épisode de la non-clef »: pour accéder à la plate-forme ultime, il faudrait ouvrir une grille constituée de barreaux de fer noirs largement espacés; à un moment. Premier Coureur tient dans sa main un cylindre d'acier finement cranté, de la taille d'un petit crayon, mais dégouttant d'huile ou de je ne sais quel produit visqueux, il le fait tourner entre son index, son majeur et son pouce. Mettons qu'il ait sorti cet objet de son logement avant moi et que la grille ait pu s'ouvrir grâce à sa tige ; toujours est-il que nous franchissons à présent la ligne d'arrivée moi derrière lui, d'autres coureurs nous rejoignent et la place est très vite peuplée d'un grand nombre de gens qui tournent lentement en rond ou demeurent assis. Sur notre gauche, une épaisse muraille en ruine domine la plate-forme: n'aimerait-on pas suivre la rampe qui la prolonge en pente douce, moitié ciment moitié rocher, ainsi qu'un large éperon descendant le long du mur de fortification? Danger pourtant, car l'aimable chemin tombe brusquement sur le vide. Afin d'interdire l'accès de cette zone, une porte ou une grille barrait jadis le plan incliné, mais il n'en reste aujourd'hui que le cadre en maçonnerie, un haut rectangle de pierre ouvert à tout vent. J'admire le panorama (comme on fait naturellement après avoir atteint un sommet), excepté que mon réflexe scopique/langagier (« magnifique ! », « sublime ! ») ne s'adresse pas au paysage réel, continue au contraire de viser l'ouverture en pierre, là-bas, où s'encadre la profondeur diaphane de l'air, rien de

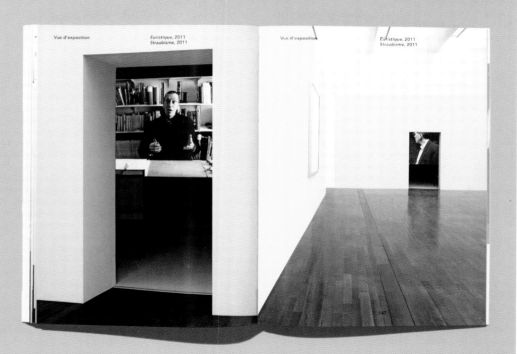

Vue d'exposition

Euristique, 2011
Straubisme, 2011

Vue d'exposition

Euristique, 2011
Straubisme, 2011

147

ABOVE

Neon Dawn
Ziyu Xu - 2018
Record album
Neon Dawn is a service for Chinese funeral
traditions. As part of the service, the user
chooses professional criers. Customers may
order a vinyl record of the funeral crying.

NEON
DAWN®
霓虹黎明
brought to you by
MANUFACTURED
PARADISE®
人造天堂

ABCDEFFGHI
JKLMNOPQ
Real™STUVW
XYZØO01234
56789äbcder
ikfghiijklmn
õpqrspiekerm
anntųvwxyż
◎Ø0123567 89

FONTFONT

FF Real

Designers:
Erik Spiekermann (b. 1947)
Ralph du Carrois (b. 1975)
2015: Berlin, Germany

Modern Versions:
FF Real Head Pro, 2015
FF Real Text Pro, 2015

Initially, Erik Spiekermann designed one text and one headline weight for his biography, *Hello, I am Erik* (Gestalten, 2014). Ralph du Carrois took Spiekermann's drawings of the alphabet, refined it, and completed the typeface. By 2015, FF Real included two styles, Display and Text, with 13 weights each. FF Real is a new generation of the historical grotesque typefaces produced in Germany at the turn of the twentieth century. The name is derived from Spiekermann's intention to design a typeface that is "the real, non-fake version, as it were, the royal sans serif face."

German grotesque typefaces may have inspired FF Real, but it has been refined to be warmer, friendlier, and less dogmatic in tone. The breadth of weights, glyphs, symbols, numeral styles, and ligatures exceeds previous neo-grotesque typefaces such as Helvetica.

SUGGESTIONS FOR SUCCESSFUL APPLICATION

➤ Unlike many other sans serif typefaces, FF Real includes true small capitals. These create a unified weight between the initial capital and small capitals.

➤ The Display style of FF Real is intended for large and headline usage. Text works with smaller sizes, incorporating kerning and letterform refinements best suited to small text.

FF REAL

» NEO GROTESQUE SANS SERIF

APPLICATIONS
Hello, I am Erik book
AIGA National Conference identity

SIMILAR
Akzidenz Grotesk
Folio
Univers
Helvetica

OPPOSITE
FF Real Wood Type
Erik Spiekermann - 2018
Poster
In addition to the multiple digital versions of FF Real, Spiekermann created a wood version for woodblock printing.

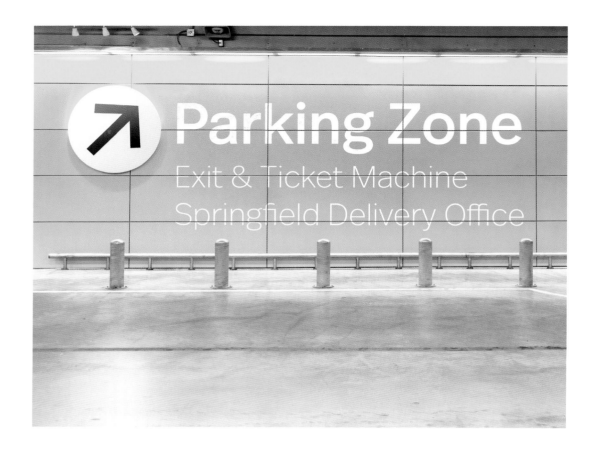

ABOVE
Springfield Parking Signage
Alexandra Schwarzwald - 2017
Signage
As a typeface with the clarity of Univers and
the warmth of Franklin Gothic, it is a perfect
choice for situations requiring legibility
without appearing clinical.

ABOVE

Geographic Data

Alexandra Schwarzwald · 2017

Informtion panels

Alexandra Schwarzwald uses a range of
weights and styles to articulate different
data. Maintaining a consistent color
and typeface helps present complex
information clearly.

FOLLOWING

Connect 2017

Sean Adams · 2017

Identity

The only typeface in the identity system for
all AIGA conferences is FF Real. A series of
postcards to announce the date is printed in
fluorescent pink.

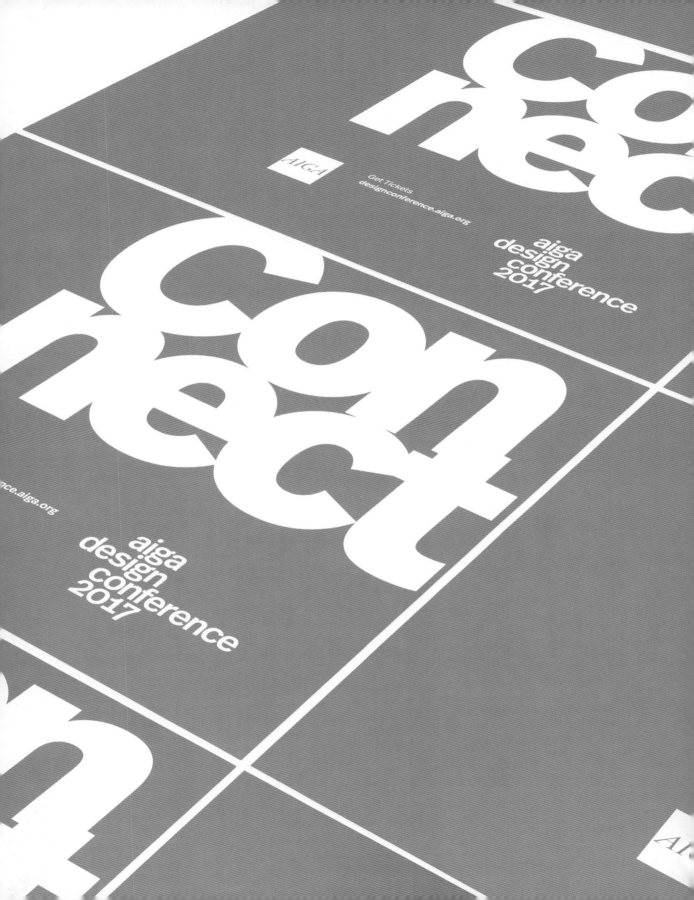

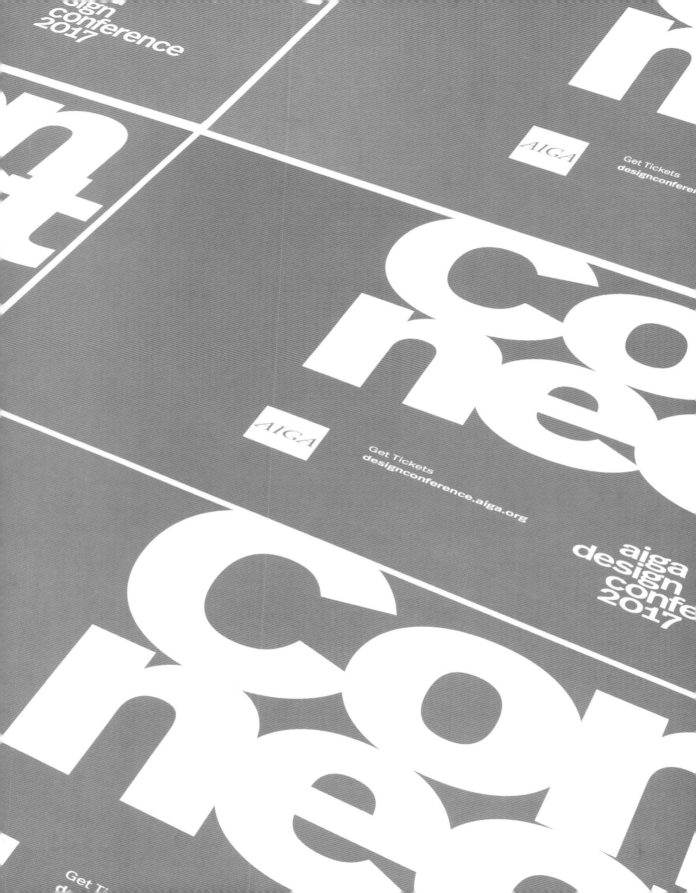

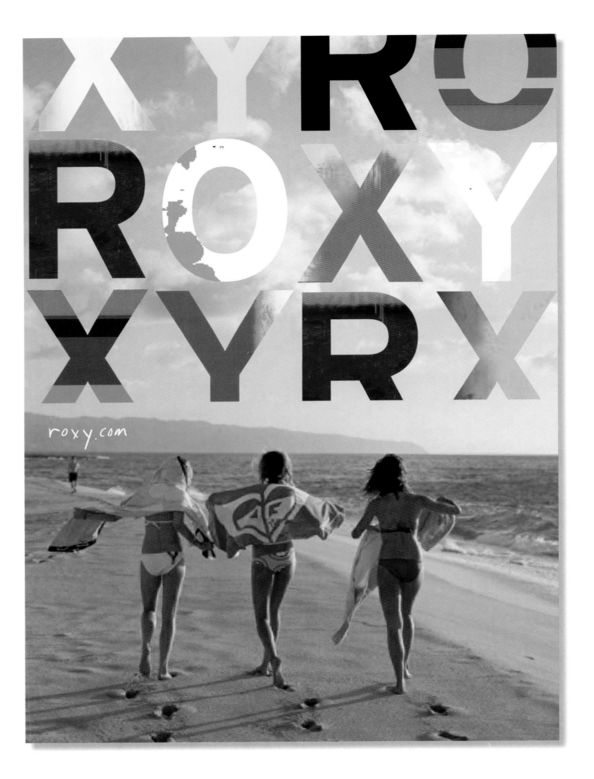

Franklin Gothic

Designer: Morris Fuller Benton
(1872–1948)
1904: New York, New York, USA

Modern Versions:
ITC Franklin Gothic, 1980
Monotype Franklin Gothic, 2001
URW Franklin Gothic, 1985

Franklin Gothic is unrelated to Gothic architecture or novels such as *Frankenstein.* Rather, "Gothic" is a name commonly given to American sans serif typefaces designed in the early twentieth century. It is equivalent to the European "grotesque." Printers and founders may have appropriated the term from blackletter Gothics popular during the Gothic Revival and Arts and Crafts movements. Franklin Gothic was not intended for book text, but for text and headlines in newspapers and advertising.

ITC Franklin Gothic, the most common modern version, modified the consistency of the family. The design historian Paul Shaw described the typeface as a failure for "mucking about with the distinctive Franklin Gothic. In ITC Franklin Gothic ... the ear on the 'g' keeps popping up like a schoolchild overly eager to answer a question."

SUGGESTIONS FOR SUCCESSFUL APPLICATION

➻ Don't mix foundry versions of Franklin Gothic (ITC, Monotype, etc.) Each version is distinctly different.
➻ Franklin Gothic has exceptional numerals. They look especially good at large sizes.

APPLICATIONS
Museum of Modern Art wordmark
Bank of America logo
Lady Gaga "The Fame Monster" album cover

SIMILAR
News Gothic
Trade Gothic
Monotype
Grotesque

OPPOSITE
Roxy
Clive Piercy: Ph.D. – 2003
Advertising
Piercy's vibrant colors, Southern California imagery, and powerfully large Franklin Gothic created a striking branded communication for Roxy, a surf, snow, and fashion brand.

FABRICE HERGOTT

AU PLUS PRÈS DU RÉEL

3

SÉBASTIEN GOKALP

L'ŒIL SAUVAGE

4

JIM LEWIS

FAIRE SON TEMPS

10

THEA WESTREICH

NOTES PERSONNELLES SUR LARRY CLARK

15

MIKE KELLEY

SOLEILS BRILLANTS POUR LA JEUNESSE

16

DOMINIQUE BAQUÉ

LA FRAGILE INNOCENCE DES CORPS DÉVASTÉS

22

FABRICE HERGOTT

AU PLUS PRÈS DU RÉEL

Avec le pouvoir entêtant d'une rengaine, il suffit d'avoir vu les photographies de Larry Clark une fois pour s'en souvenir toujours. Qu'elles soient délicates ou crues, elles se gravent littéralement dans l'esprit, dans une zone de la perception qui semble plus profonde encore que la mémoire, quelque part entre le cœur et les os. On regarde, mais on se sent regardé, impliqué et curieusement associé à ce qu'elles montrent. Il n'est pas possible d'être plus loin du voyeurisme et de l'exhibitionnisme du monde d'aujourd'hui, plus loin de cette forme de pornographie feutrée qui a tout envahi. Ici, pas de regard avide de consommateur, pas de corps-objet instrumentalisé et formaté pour des émotions comptables, pas de cannibalisme dissimulé, mais au contraire, une complicité et une sympathie hors mesure entre les sujets et le photographe. L'indécence de Larry Clark vient de ce qu'il porte un regard personnel et intériorisé. Son regard est curieux, étonné de ce qu'il voit. Chaque image porte avec elle cet étonnement, la surprise d'avoir pris une photo. Il ne cherche pas à faire de la belle photographie. Il ne cherche pas d'autre où à être là, à se fondre dans ce qu'il voit, un œil invisible qui passe au milieu de ses amis comme au milieu d'ombres sans qu'ils ou elles semblent le remarquer plus d'un instant.

Il suffit de s'arrêter sur les regards, de tenter de comprendre sa position par rapport à la lumière. Il photographie depuis la partie la plus obscure de la pièce, presque toujours à contre-jour ou point que ce dernier en devient presque sa marque de fabrique. Trop jeune dans les années 1960, un peu décalé, et sans assurance, il semble aujourd'hui, et malgré sa célébrité, tout aussi décalé. Peut-être parce qu'il est trop vieux, ou d'une autre culture, ses photographies continuent à chercher leur place du regard. Et comme avant, elles cherchent là où il n'y avait rien avant lui. Entre les photographies prises il y a quarante ans et celles faites récemment à Los Angeles, subsiste cette même sensation que le photographe est présent sans participer à qu'il voit. L'appareil photo lui permettant sans doute de caler un objet entre lui et ses sujets comme on le fait d'un morceau de carton sous une table - que bouge -, de façon à ce que tout se passe sans questions et, au bout du compte, sans problèmes. La photographie dissout alors instantanément le pourquoi. Elle est l'évidence. Elle se moque du discours. Elle se moque du rôle moral qu'elle peut jouer en

3

montrant ce qui a été là, ce qui a été le sujet ou l'auteur d'une bonne image.

L'œuvre de Larry Clark est complexe, multiforme, élaborée sur des décennies. Elle fait entrer le spectateur dans un univers où il se retrouve si proche de ce qui est montré qu'il n'en sort jamais indemne. Il est impossible de ne voir sa photographie qu'à travers ses sujets et comme par-dessus son épaule. Est-ce une œuvre autobiographique? Montre-t-elle le monde tel qu'il est? Donne-t-elle une vision personnelle de ce que nous vivons, pourrions ou avons pu vivre? En commençant dans les années 1960 en photographiant l'intérieur de la petite bourgeoisie américaine, il établit un parallèle entre le désarroi qui règne au cœur de villes de province comme Tulsa et celui des camps militaires du Vietnam. Dans ses incohérences, l'Amérique est cohérente. S'il est facile de dire que le monde se délite et que les artistes, et Larry Clark en premier, ont montré que le monde réel n'est plus celui dans lequel nous vivons, ce n'est pas seulement un procès fait à notre monde. Nous savons déjà que le temps est changé, que nous vivons dans un monde absurde, fait de faux-semblants et de tromperies, de croyances et d'illusions, de guerres falsifiées et de paix atroces. Dans ce monde où tout est factice, le réalisme de Clark est une hypothèse. Il nous parle de quelque chose qui va au-delà de notre pensée. Il recherche, pour reprendre ses termes, «la vérité».

L'importance des plus grandes œuvres peut ne pas se faire sentir immédiatement. Elle prend parfois des chemins détournés et passe dans un premier temps par l'imaginaire populaire, les magazines, la publicité, apparaît et se fond avec le mode et avec ce qu'elle a de plus précaire. On croit que ce n'était que l'écume d'une époque, mais vingt ans plus tard, au détour d'une image, on comprend que cette écume est toujours là, qu'elle s'est cristallisée et qu'autour d'elle se sont regroupés d'autres œuvres, d'autres artistes.

Ne jamais être un observateur distant, photographier la réalité au plus proche, sans juger. Une capacité à regarder en étant totalement présent, sans la distanciation que sous-tend la curiosité du voyeuriste. Larry Clark est là avec évidence dans chaque scène photographiée, une manière de s'inscrire dans un monde dont la photographie authentifierait la réalité, mais qui paradoxalement n'a peut-être existé que pour ces prises de vue. Le tout emprunt d'une nostalgie infinie. Cela appartient au passé et seul reste cet arrangement d'ombres dont les modèles sont déjà loin. Elles possèdent les vertus universelles d'une mythologie moderne, celle de l'Amérique perdue que nous portons en nous comme les anciens Grecs devaient vivre avec l'Iliade. Larry Clark donne forme à ce mythe en lui apportant une dimension respectable dans sa manière de traiter l'intimité, la relation aux autres et à soi. C'est un art de la perte, de l'oubli, des jeun

LARRY CLARK KISS THE PAST HELLO

LUHRING AUGUSTINE
NEW YORK

SIMON LEE GALLERY
LONDON

FRANKLIN GOTHIC

» GROTESQUE SANS SERIF

OPPOSITE AND ABOVE
Kiss the Past Hello, Larry Clark
Spassky Fischer - 2010
Book
Spassky Fischer beautifully pairs an industrial
and straightforward Franklin Gothic with
Larry Clark's raw and blunt imagery.

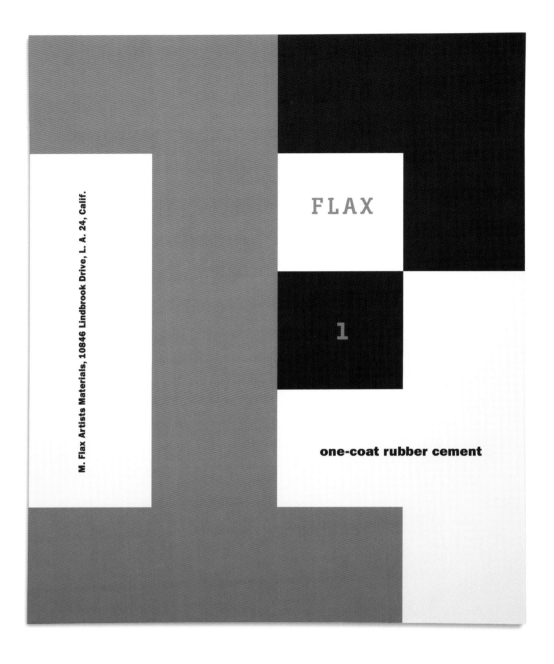

M. Flax Artists Materials, 10846 Lindbrook Drive, L. A. 24, Calif.

FLAX

1

one-coat rubber cement

ABOVE
Flax
Louis Danziger ~ 1959
Advertising
The Flax logo is a set of perfect squares.
To offset the rigidity of the mark, Danziger
applied Franklin Gothic as the text typeface.

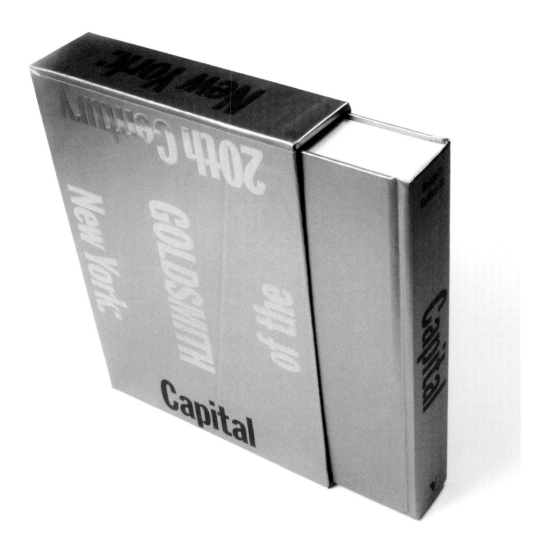

ABOVE
Capital: New York, Capital of the 20th Century
Neil Donnelly, Andy Pressman: Neil Donnelly Studio - 2015
Book
Capital is a collection of writings about New York. The exterior
references Kenneth Goldsmith's assertion that the city is "all
surface." The typography is a nod to the urban vernacular
typography of New York City.

FOLLOWING
L'Autre de l'Art
Emmanuel Labard: unit - 2014
Poster campaign
"The Other Art" at Lille Métropole Museum
of Modern Art was an exhibition exploring the
influences and origins of twentieth-century
art through the lens of outside influences.

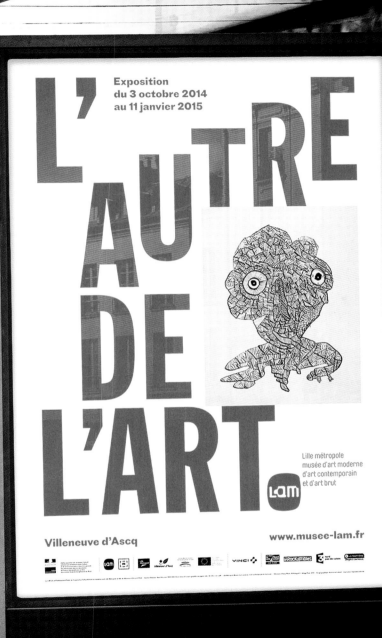

THE COOPER UNION SCHOOL OF ART & ARCHITECTURE

Futura

Designer: Paul Renner (1878—1956)
1927: Frankfurt am Main, Germany

Modern Versions:
Bitstream Futura, 1927
Linotype Futura, 1936
ParaType Futura, 1991
Futura ND, 1999

In the 1920s, designers at the Bauhaus aspired to a pure form of design governed by mathematics. Designers, architects, and artists strove to abandon the excess of the Victorian age and find solutions for the masses. Good, straightforward forms would create a good life. Paul Renner, inspired by these concepts, designed Futura. He rejected the traditional Gothic blackletter typefaces popular in Germany at the time, instead designing Futura using meticulous geometry. An "O" was a perfect circle. The strokes of a "T" were uniform and even. For Renner, Futura represented efficiency and a modern way of life. The Bauer Type Foundry released Futura with the slogan "The Typeface of Today and Tomorrow."

Today, Futura continues to represent modernism and efficiency. Its incorporation into countless science-fiction movies, including *2001: A Space Odyssey*, has reinforced its connection with the future and mechanical purity.

SUGGESTIONS FOR SUCCESSFUL APPLICATION

➥ In metal form, Futura included multiple versions for each size. The digital versions have only one. Open the letterspacing slightly for small text sizes. Tighten it for headlines to compensate for the optical issues.

➥ Futura's ascenders are tall compared to the x-height. Additional leading helps legibility and its "spotty" appearance.

APPLICATIONS
Volkswagen advertising
2001: A Space Odyssey poster

SIMILAR
Erbar Grotesk
Avenir
Brandon Grotesque

OPPOSITE
The Cooper Union
Herb Lubalin, Tony DiSpignia: Lubalin, Smith, Carnase ~ 1974
Logo
Along with his students at the Cooper Union, Herb Lubalin entered a contest to design a new logo for the school. Unfortunately, his design, here, came in second and was not used.

BOAC
747

more sitting room in the sky

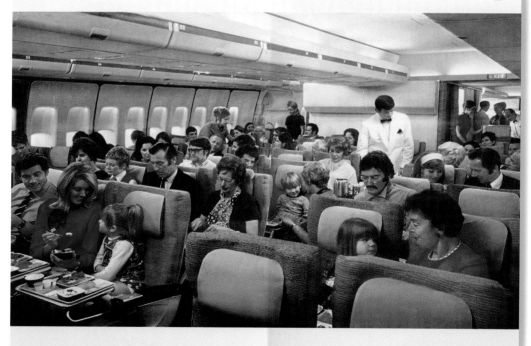

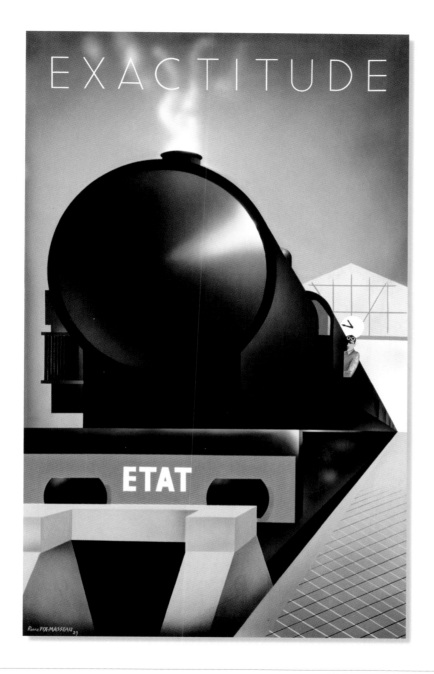

EXACTITUDE

ETAT

OPPOSITE
BOAC 747
British Airways - 1971
Poster
To promote the width of the Boeing 747, the designer ran Futura Bold across the width of the poster from edge to edge. The staged photograph below illustrates the living room feeling of the interior.

ABOVE
Exactitude
Pierre Fix-Masseau - 1929
Posters
Masseau, in Paris, worked with the same concepts as Renner, creating a purely geometric letterform that was heavily influenced by Futura.

ABOVE AND OPPOSITE
Ingelsta Shopping
BVD Stockholm AB ~ 2008
Signage
The circular, bright, and multicolored disks
with Futura and playful icons add levity and
a light touch to Ingelsta, one of Sweden's
foremost retail establishments.

FOLLOWING
Good Manners
Educational Services ~ 1952
Posters
During the 1950s, elementary school
teachers hung these posters to promote good
behavior. The friendly illustrations depict
the situations described by each poster.

Make Introductions EASILY

GOOD CARE

makes them last

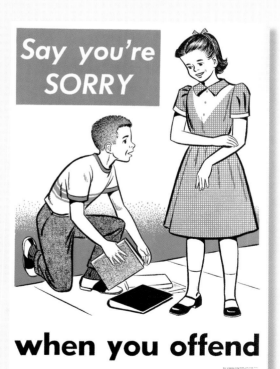

Say you're SORRY

when you offend

Be Smart !

Take care of your clothes

PENGUIN
BOOKS

COMPLETE UNABRIDGED

Gill Sans

Designer: Eric Gill (1882—1940)
1928: Buckinghamshire, UK

Modern Versions:
Monotype Gill Sans, 1928
Monotype Gill Sans Nova, 2015

After designing Perpetua, Eric Gill turned to the design of a sans serif typeface. Influenced by Edward Johnston's typeface for the London Underground, Gill painted a sign for a bookstore in Bristol, England. He also included the alphabet of the typeface for future usage on sales promotions, posters, and other ephemera. In 1927, Stanley Morison, at Monotype, commissioned Gill to develop the typeface as competition against German geometric typefaces. The result, Gill Sans, borrowed from Johnston Underground and classical serif letterforms. Rather than designing forms with perfect geometry, Gill Sans is irregular. The non-uniform nature is more human than mathematical.

During the 1950s and 1960s, British designers moved away from Gill Sans in favor of neo-grotesque typefaces such as Helvetica and Akzidenz Grotesk. Today it has both a governmental utilitarian and a quaint and nostalgic character, applied to informational design and vintage-oriented design.

SUGGESTIONS FOR SUCCESSFUL APPLICATION
➤ While carrying the name Gill Sans, certain weights such as Ultra Black have little visual relation to the rest of the family.
➤ A common mistake is to heavily letterspace Gill Sans capital letters and use similar leading. Make sure to increase the leading to avoid a jigsaw-puzzle effect.

APPLICATIONS
LNER brand identity
BBC identity
Penguin Books covers
Tommy Hilfiger logo

SIMILAR
Kabel
Granby
Bliss
Johnston's Railway
Type
FF Yoga Sans

OPPOSITE
Nineteen Eighty-Four
David Pearson - 2013
Book cover
George Orwell's *Nineteen Eighty-Four* is set in Great Britain, now part of Oceania and ruled by a totalitarian political party. To maintain power, the government issues a new dictionary each year eliminating unnecessary words. The destruction of language is powerfully communicated with the censorship bars here.

BELOW
Riso d'uomo
Here Design ~ 2017
Packaging
Here applied the typeface Granby for the
packaging of Italian risotto rice. Stephenson
Blake designed Granby as the competition to
Gill Sans. The shapes relate to the terracotta
patterned floors of Duomo di Milano.

OPPOSITE
Wise by Patagonia
Lovisa Boucher ~ 2017
Packaging
As a proposed concept for Patagonia, Wise is
a line of body care products that encapsulate
Patagonia's values of sustainability and
responsible environmental practices.

FOLLOWING
Das Englische Buch im Zeitalter der
Romantik
Catharina Elisabetha Weidtmann ~ 2013
Outdoor display
Displayed on Kurfürstendamm in Berlin,
these posters are for an exhibition about
English books in the age of Romanticism.

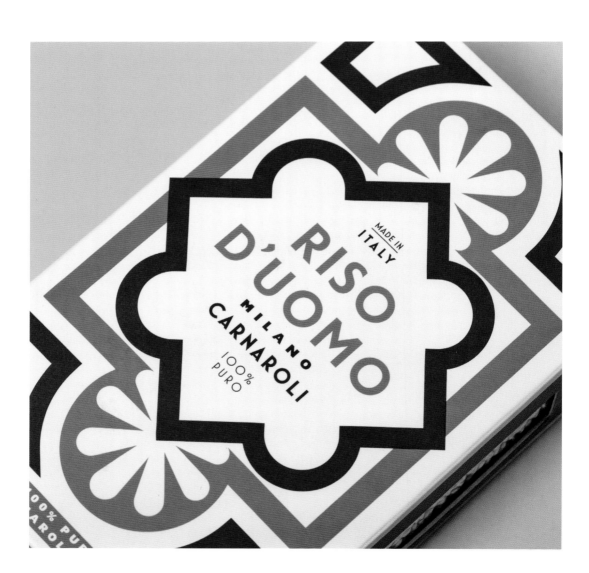

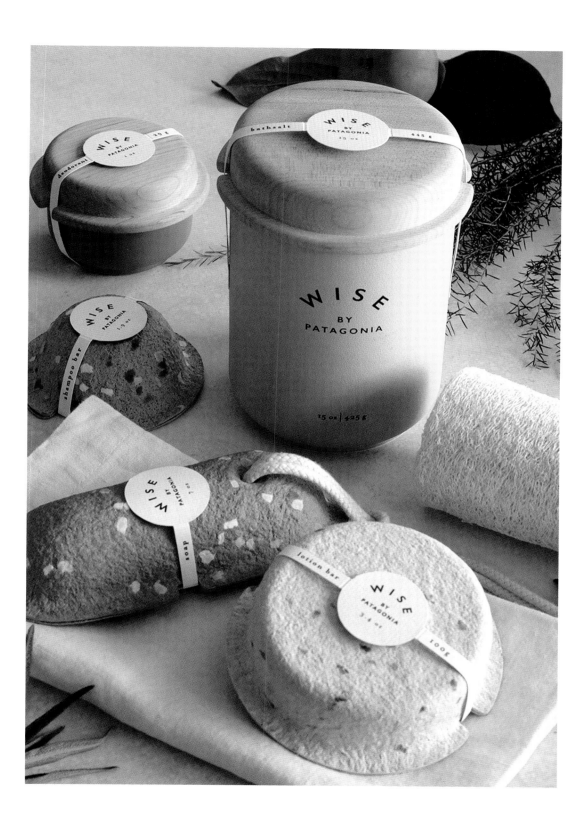

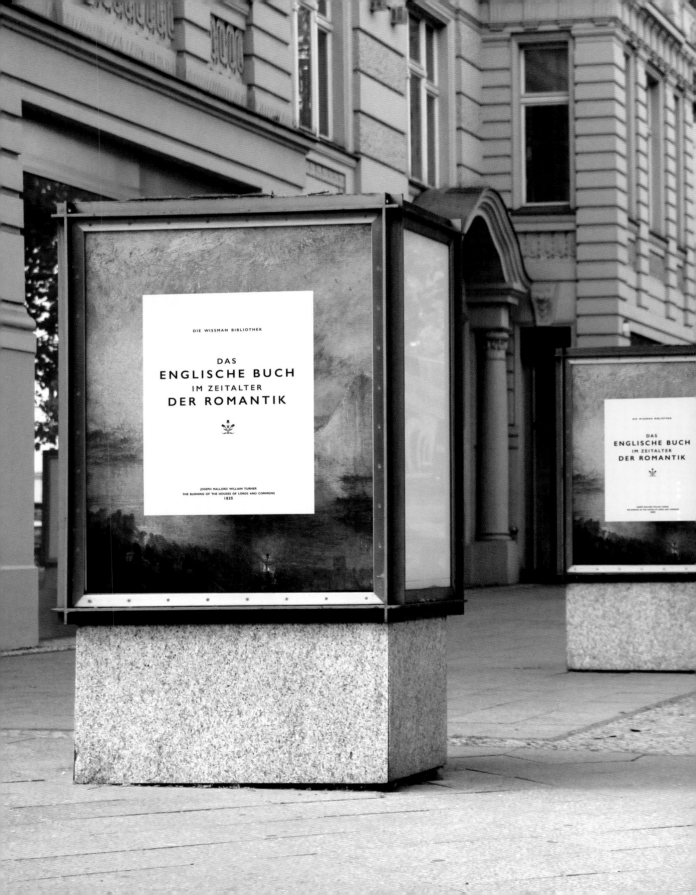

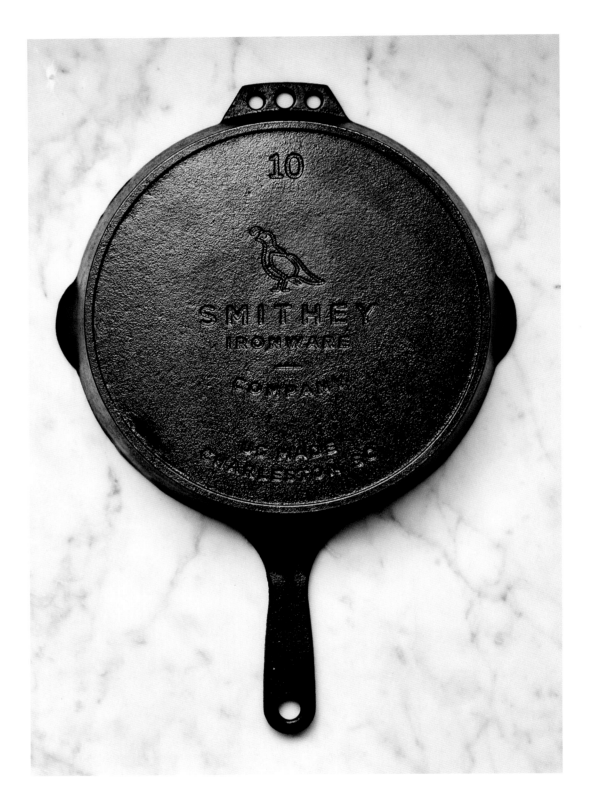

Gotham

Designer: Tobias Frere-Jones (b. 1970)
2002: New York, New York, USA

Modern Versions:
HTF Gotham, 2002

In 2002, *GQ* magazine commissioned the type foundry Hoefler & Frere-Jones to design a masculine, geometric sans serif typeface. Tobias Frere-Jones turned to the vernacular of New York City signage for inspiration. While Renner designed Futura to create mathematical purity and social harmony, Frere-Jones was interested in the straightforward American sign-painting approach. He designed Gotham based on a square grid to emulate the process of a sign painter or stone mason. However, to maintain a warmer, less clinical tone, he allowed some of the letterforms to exceed the grid. Gotham feels authentic and reliable. It has a no-nonsense attitude, but its irregularities add a human touch, producing a friendlier impression.

SUGGESTIONS FOR SUCCESSFUL APPLICATION

➻ Gotham is legible at small and large sizes. It is appropriate for body text and caption information.

➻ If mixing Gotham with a serif typeface, choose a rounder typeface such as Archer, Bodoni, or Clarendon.

133

APPLICATIONS
Barack Obama 2008 presidential campaign
Spotify logo
Martini & Rossi packaging

SIMILAR
Metro
Interstate
Brandon Text
FF Mark
Avenir
ITC Avant Garde

OPPOSITE
Smithey Ironware
Amy Pastre, Courtney Rowson: SDCO Partners ~ 2016
Branding
For the Smithey Ironware Company, SDCO Partners designed an identity system that relates to the industrial nature of the product. Not only does Gotham communicate the idea, it is simple and easy to read when stamped into an iron skillet.

CURTIS
INSTITUTE OF MUSIC

CURTIS
INSTITUTE OF MUSIC

CURTIS
INSTITUTE OF MUSIC

CURTIS
INSTITUTE OF MUSIC

CURTIS
INSTITUTE OF MUSIC

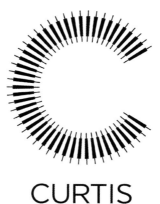

CURTIS
INSTITUTE OF MUSIC

ABOVE
Curtis Institute of Music
AdamsMorioka · 2006
Identity
The logo for the Curtis Institute of Music in
Philadelphia is a set of Gotham-shaped "C"
letterforms made with a variety of musical
notations and patterns.

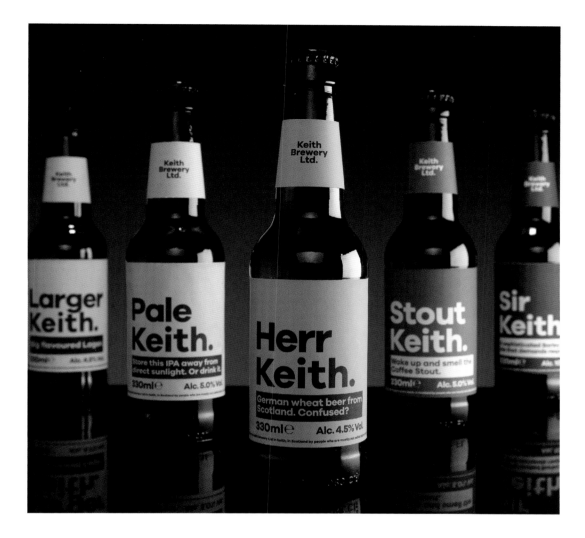

ABOVE
Keith Brewery
Nick Cadbury: Threebrand - 2015
Packaging
The Scottish beer packaging market is loud and competitive. Threebrand designed a standout by being quietly confident, caring more about the beer than the labels. The typeface is related to Gotham, Galano Grotesque.

FOLLOWING
Alchemika: Caterina Albert Library
Cómo Design Studio - 2012
Signage program
Housed in an old plastics factory, the Caterina Albert Library's signage integrates with the history and architecture of the building. The geometric forms and simple black, white, and red color palette stand out against the white walls.

CIÈNCIES SOCIALS
FILOSOFIA I PSICOLOGIA
HISTÒRIA I GEOGRAFIA
RELIGIONS
INFORMACIÓ

SALA D'ACTES
ALCHEMIKA

Design Museum Barcelona

Museu del Disseny
de Barcelona

14.12.2014

Formerly housed at different sites
and following different trajectories,
the Museu del Disseny de Barcelona
is now located at the DHUB building.
Organised around the theme "from the
decorative arts to design" it focuses on
4 branches or design disciplines: space
design, product design, information
design and fashion. The museum itself
conserves more than 70,000 objects,
the result of merging the collections
of the Museum of Decorative Arts. The
new space contains a rich and diverse
collection of European decorative arts
and design, including The Museum of
Textile and Clothing, The Graphic Arts
Cabinet, and The Museum of Ceramics.
The Museum also hosts a library Centre
de Documentació, dedicated to the
greater areas in the world of design:
product, fashion, information and
interior design. In addition to this, the
Museum will hold various exhibitions,
lectures, workshops, activities,
educational services and courses.

Graphik

Designer: Christian Schwartz (b. 1977)
2009: London, UK, and
New York, New York, USA

Modern Versions:
Graphik, 2009

In the mid-1950s, multiple foundries designed typefaces to compete with the hugely popular European sans serifs: Helvetica, Univers, and Futura. None of these reached the level of popularity of the big three, but each had elements that succeeded. Neuzeit Grotesk, Folio, and Recta all followed the tradition of European neo-grotesque typefaces. In 2008, Christian Schwartz designed Graphik, inspired by these lesser-known typefaces.

Graphik is designed for plainness. It is meant to be neutral and unassuming. Graphik is less precise than Univers, adding a contemporary and more human tone. It is a successful alternative to the ubiquitous Helvetica and Univers, with its expertly crafted letterforms and consistency as a family.

SUGGESTIONS FOR SUCCESSFUL APPLICATION

➻ Details, such as the round dot on the "i," add a playful touch to Graphik. It works well to communicate authority without dominance.

➻ Sabon is a good companion for Graphik. It has the same mid-century dynamic and refined forms.

APPLICATIONS
Hidraulik packaging
GD& publications
Karla Black + Kishio Suga exhibition identity

SIMILAR
Akzidenz Grotesk
Folio
Helvetica
Neuzeit Grotesk
FF Real

OPPOSITE AND FOLLOWING
Design Museum Barcelona
Atlas ‑ 2014
Identity system
Atlas's bold system for the identity of the Barcelona Design Museum is designed to accommodate the multidisciplinary and varied content of the museum. The connecting line on all pieces refers to the building's geographic location at the crosspoint of Avinguda Diagonal, Avinguda Meridiana, and Gran Via de les Corts Catalanes.

Exposició

**El disseny gràfic:
d'ofici a professió
(1940-1980)**

Auditori-Foyer
Auditorio-Foyer
Conference Hall-Foyer

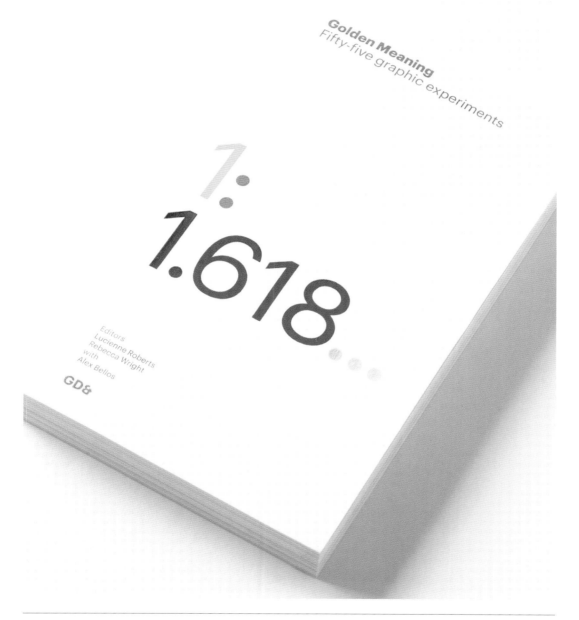

Golden Meaning
Fifty-five graphic experiments

1:
1.618...

Editors
Lucienne Roberts
Rebecca Wright
with
Alex Bellos

GD&

Theatre Magazine #23
Natasha Agapova: Arbeitskollektiv - 2016
Publication

Teatr. is the oldest existing Russian theater
magazine, founded in the 1930s. Agapova's
application of Graphik's Cyrillic alphabet
brings the content clearly up-to-date for
modern life.

ABOVE
Golden Meaning
Lucienne Roberts, Rebecca Wright - 2014
Book

Roberts and Wright challenged 55 creatives
to interpret the golden ratio (1.618). The
book itself is a golden rectangle and the title
numerals are printed with a gold foil.

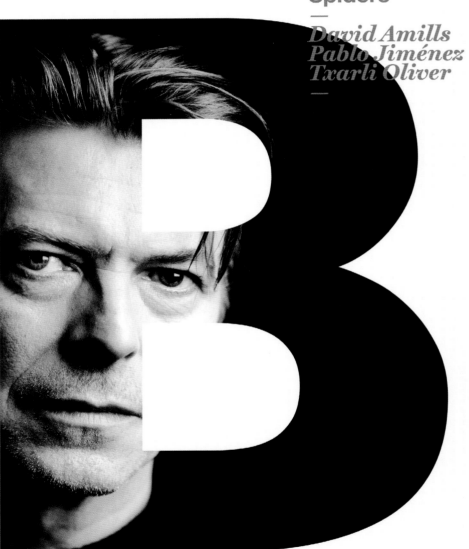

Entrada lliure
23.45h

**10 Gener
Atlàntida
Bar Vic**

Concert
Homenatge
Bowie 67

Aladdin
Spiders
—
*David Amills
Pablo Jiménez
Txarli Oliver*
—

Helvetica

Designer: Max Miedinger (1910–1980)
1957: Basel, Switzerland

Modern Versions:
Linotype Helvetica, 1961
Helvetica Neue, 1983

In the mid-1950s, Eduard Hoffmann, the director of Haas Type Foundry, commissioned Max Miedinger to design a sans serif typeface to compete with Akzidenz Grotesk. Miedinger saw this as an opportunity to refine Akzidenz Grotesk's irregularities and create a more cohesive family. Designers and creative directors at advertising agencies embraced the resulting typeface for its objective International Style clarity. Helvetica lacked any superficial features or fanciful choices. It was built to be efficient and work in any setting.

Helvetica is ubiquitous. Its versatility allowed for use on logos, posters, signs, vehicles, and printed matter. Its usage became even more widespread when Microsoft and Apple incorporated the typeface into their operating systems. Today, Helvetica can be invisible. It has become background wallpaper.

SUGGESTIONS FOR SUCCESSFUL APPLICATION

➤ For strong effect, use Helvetica large and bold or extremely small. Medium-weight, medium-size Helvetica will recede and go unnoticed.

➤ Due to its uniform design, Helvetica is difficult to read as body text. Try mixing a Helvetica headline with a serif typeface.

HELVETICA

» NEO-GROTESQUE SANS SERIF

APPLICATIONS
Apple iOS system font
Target logotype
New York Subway signage (modified)
3M logo

SIMILAR
Akzidenz Grotesk
Folio
Univers
Unica
FF Bau
Akkurat

OPPOSITE
Concert Homenatge Bowie 67
Quim Marin - 2014
Poster
Marin inserts David Bowie's portrait into the powerful Helvetica capital "B" letterform on this poster for a concert in homage to Bowie. The minimal form and face looking at the viewer stand out in a crowded urban environment.

An Italian symbol identifying the location of a fire hose and hydrant uses simplified forms and clear Helvetica to aid legibility and easy identification regardless of langauge.

Utopia Limited, or The Flowers of Progress is a Gilbert and Sullivan opera. The plot is a satire on British conventions of the nineteenth century. Winkler brings a modern touch with Helvetica and a simple color palette.

IDRANTE

Utopia
Utopia L
Utopia Lt
Utopia Ltd
Ltd

Or The Flowers of
Progress
By W.S. Gilbert and
Arthur Sullivan

Auditions
September 29, 30
October 1, 2, 1969
7:30 pm
Kresge Auditorium
Rehearsal Room B

Presented by the
MIT Gilbert and
Sullivan Society

Performances
November 20, 21, 22
1969, 8:30 pm
Kresge Auditorium
Massachusetts
Institute
of Technology

BELOW
Chair
Peter Bradford ~ 1972
Book
The brutalist and direct design of this
book on chair design, typeset entirely in
Helvetica, is offset with color and lively
imagery. The design succeeds thanks to its
relentless commitment to the approach.

FOLLOWING
Muceum
Spassky Fischer ~ 2016
Identity program
The identity program for a museum
needs to be bold, yet not compete with
the content. Spassky Fischer achieves
this with large-scale typography and an
unexpected bright palette.

Chair

The current
state of the art,
with the who,
the why, and
the what of it.
Produced by
Peter Bradford
Edited by
Barbara Prete

Established 1834

Thomas Y. Crowell
New York

Du 15 au 1

Cinéma

Mu

Spectacles

Plan B

Vendre

Sou
arge

Mucem

Journées
Graff, calli

Théâtre, da

Con
Déti
Rec

25 – 29 juillet, plage du Prado
1er – 5 août, fort Saint-Jean

Lʹ

Carte blanc
portugaise,

Roger Berna
Bouchra Oui

Mu

Ob
dép

Mucem

Décembre 2

P

Mucem

De la plage au musée, de l'apéro aux expos

ouvertes

Portes

Mucem
Octobre Novembre
Décembre

2017

Tournons autour du Mucem, de la Friche la Belle de Mai, du Vieux-Port. Passons derrière le comptoir, devant le percolateur, le long de la course de garçons de café. Tournons autour de cette petite cerise rouge du docteur Le Plé, celle qui fut longtemps cultivée au Yémen, celle qui a transformé Cuba. En équilibre, avec un plateau, autour de tables savoureuses, mélons au café, réglisse, whisky, crumble, *granite* et meringue. Tournons davantage et passons de la génétique du café à son addiction, de ses mystères à ses vertus, du *Coffee* aux *cigarettes*, de la baie à la tasse. Déambulons, avec gourmandise, à travers ses mille et un secrets, à la rencontre de torréfacteurs, autour de cafetières Alessi, du côté de la cafédomancie, tout autour d'une pratique qui nous est tant familière.

26 oct. 2016 – 23 janv. 2017 Rendez-vous autour de l'exposition « Café in »

Café off
Mucem

26 oct. 2016 – 23 janv. 2017 Rendez-vous autour de l'exposition « Café in »

Décembre 2016 – mars 2017

Plans

Bâtiment J4

Fort Saint-Jean

Plan général

Dezember 2016 – März 2017

Pläne

Gebäude J4

Fort Saint-Jean

Allgemeiner Plan

December 2016 – March 2017

Maps

J4 building

Fort Saint Jean

General map

Diciembre de 2016 – marzo de 2017

Planos

Edificio J4

Fuerte Saint-Jean

Plano general

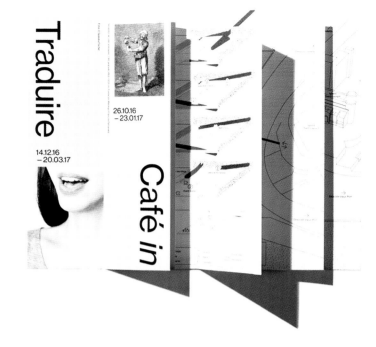

Traduire

26.10.16
– 23.01.17

14.12.16
– 20.03.17

Café in

dénoncer une société matérialiste et superficielle. Le roman-photo mérite de ne pas être systématiquement subordonné à une image rétrograde, bien au contraire! J'ajoute que le roman-photo pas mort: le magazine Nous Deux, est vendu chaque semaine à 250 000 exemplaires en France. De plus, cette forme d'expression est actuellement réinventée par de nouveaux acteurs qui l'utilisent pour des projets documentaires, artistiques, satiriques. Alors cette exposition est tout à fait raisonnable pour un musée de société comme le Mucem!

M. Comment est né ce projet? Êtes-vous-même une lectrice assidue de romans-photos?

F.D. Je n'en avais jamais lu jusqu'au jour où, il y a une dizaine d'années, mon regard s'est posé sur une pile de Nous Deux qui partait à la benne. Je me suis dit: «Mais ça existe encore!» J'étais alors iconographe dans un groupe de presse et comme je m'intéresse beaucoup à l'image, j'ai décidé de faire une enquête sur ce curieux sujet. Au fil des découvertes, il m'a paru évident que cette histoire pouvait être racontée sous la forme d'une exposition.

M. De quelle façon le Mucem a-t-il abordé le sujet?

M.-C.C. Pour le Mucem, il était important de traiter du roman-photo en tant que phénomène de société. De sa naissance durant l'après-guerre à la façon dont il a su évoluer – ou pas – avec son temps. C'est une exposition à prendre au premier et au second degré. Dans le sens où l'on peut, d'une part, l'aborder sous l'angle de la photographie, en ayant un contact direct à l'image, et, d'autre part, regarder ces images en les replaçant dans leur contexte historique et sociétal. Pour nous, il s'agit toujours de montrer en quoi le roman-photo est le témoin de la société de son temps. Le Mucem était aussi sensible à la dimension méditerranéenne de ce moyen d'expression qui a connu un succès phénoménal dans tout l'arc méditerranéen, alors qu'il peinait à s'exporter dans les pays anglo-saxons. Ce projet offre en outre au musée l'occasion d'interroger son vaste fonds autour de l'imagerie populaire.

M. L'exposition s'articule en deux parties. La première s'intéresse à l'histoire du «vrai» roman-photo...

F.D. Le «vrai» roman-photo, c'est le roman-photo sentimental, né en 1947, et que l'on

trouve encore aujourd'hui dans Nous Deux. Dans l'exposition, objets, images, couvertures et maquettes originales retracent son évolution depuis ses origines jusqu'à nos jours. Le parcours mène jusqu'à – salon de lecture – des années 1960-1970, dans lequel des exemplaires de Nous Deux seront à disposition du public qui pourra les feuilleter, et même en emporter.

M. L'exposition montre dans sa deuxième partie que le roman-photo n'est pas seulement une histoire à l'eau de rose.

F.D. Ce moyen d'expression – le savoir un récit avec des photographies et des bulles – a en effet été repris et détourné de façon, très diverses. L'une des productions les plus importantes fut celle du genre «érotico-pornographique» – que nous traitons dans l'exposition au sein d'une salle interdite aux moins de 18 ans. Nous montrons aussi le roman-photo satirique avec Hara-Kiri et le Professeur Choron puis la façon dont les situationnistes se sont emparés du genre pour le détourner à des fins politiques. Enfin, la dernière partie s'intéresse à la veine «artistique» du roman-photo à partir de La Jetée, le film de Chris Marker qui, faut-il le rappeler, est sous-titré «photo-roman».

M.-C.C. Il est aussi intéressant d'observer de quelle manière les détracteurs du roman-photo – intellectuels, catholiques et communistes – ont eux-mêmes eu recours à ce moyen d'expression: nous avons par exemple retrouvé une revue intitulée Famiglia Cristiana, qui raconte la vie des saints en roman-photo... alors même que l'Église dénonçait le genre comme immoral. Dans un tout autre domaine, nous donnerons à voir les décors (dont une Fiat 500 coupée en deux!) d'un spectacle de la compagnie Royal de Luxe qui raconte un tournage de roman-photo.

M. Parmi les pièces les plus remarquables, l'exposition présente le fonds Mondadori, constitué d'originaux jamais montrés jusqu'à present.

F.D. Lorsque nous avons débuté ce projet, il était pour nous hors de question de proposer une exposition uniquement constituée de magazines sous vitrines. Cependant, le roman-photo n'ayant jamais été considéré comme un art, les matériaux originaux qui avaient servi à son élaboration (maquettes, photographies, négatifs) sont

33

Muc
em

Psc

Muc
Ma
20

Mu
Ma
20

Mu
Ét
20

Mu
Se
20

Mu
No
20

Mu
Ja
20

Mu
Ma
20

Mu
Ju
20

Mucem
Sept.–oct.
2016

Reinventing the Wheel

JESSICA HELFAND

Knockout

Designers:

Jonathan Hoefler (b. 1970)

Tobias Frere-Jones (b. 1970)

1994: New York, New York, USA

Modern Versions:

Hoefler & Co. Knockout, 1994

There are few sans serif typefaces with a vast family of styles and weights. Jonathan Hoefler and Tobias Frere-Jones designed Knockout to fill that void. The typeface is related to other American Gothic typefaces, such as News Gothic and Franklin Gothic. It is not as overly precise as Univers and Frutiger, and retains a character that is bold and aggressive.

The family consists of four weights, from thin to extra bold. Each weight also includes a range of nine styles, from extremely condensed and vertical to highly expanded. Unlike Franklin Gothic, Knockout works as a unified family, with condensed and compressed versions that seem visually related.

The typeface and individual style names refer to boxing (or Japanese Sumo wrestling) terms, alluding to the connection between the rough-and-tumble, bold, and utilitarian spirit of Knockout.

SUGGESTIONS FOR SUCCESSFUL APPLICATION

➻ One of Knockout's great strengths is the option of pairing extended and condensed versions seamlessly.

➻ The more extreme styles such as Flyweight (ultra compressed) and Sumo (super extended) are not suitable for text. Most of the other styles, however, will work as body copy or in a smaller setting.

APPLICATIONS
The Public Theater logo
United States Postal Service signage
Royal College of Art website

SIMILAR
Franklin Gothic
Trade Gothic
News Gothic
Monotype
Grotesque

OPPOSITE
Reinventing the Wheel
Jessica Helfand, Kevin Smith: Winterhouse Studio - 2002
Book
Helfand presents the history of the wheel in information design with examples from the fourteenth to the twentieth centuries. The wheels, often movable, are the ancestors of modern interaction design.

ABOVE
Becoming Los Angeles
AdamsMorioka - 2013
Exhibition design
The Natural History Museum of Los Angeles
County's permanent exhibition covers the
history of Los Angeles. Giant dates and events
guide the viewer through the large exhibition,
identifying not where they are, but when.

FOLLOWING
Shakespeare in the Park
Paula Scher: Pentagram - 2018
Poster campaign
Knockout is key to the Public Theater's identity.
For the 2018 season, Scher used the multiple
weights and widths to animate the content. In
digital form, the letters expand and contract.

GATE **1**

PUBLIC.

GATE **2**

PUBLIC.

GATE **3**

PUBLIC.

REST-ROOMS →

ACROSS FROM GATE 2

PUBLIC.

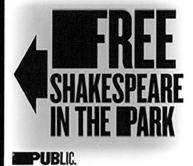

← FREE SHAKESPEARE IN THE PARK

PUBLIC.

← REST-ROOMS

ACROSS FROM GATE 2

PUBLIC.

PUBLIC.

BOX OFFICE

PUBLIC.

SECTIONS

← CDENO

PUBLIC.

BO

GATE 4

GATES 1 & 2 →

GATES ← 3 & 4

WE RESERVE THE RIGHT TO INSPECT ALL BAGS

← FREE SHAKESPEARE IN THE PARK

FREE SHAKESPEARE IN THE PARK →

LAST NAMES A–L

SECTIONS ABCFG →

OFFICE

LAST NAMES M–Z

Fall 2016

**ArtCenter MGx Graphic Design Program
Visiting Artist Series**

10.24 11.7–11.9 11.14–11.17 11.28

Week 07
Paul Hoppe

Week 09
Lutz Engelke Workshop

Week 10
Erik Spiekermann Workshop

Week 12
Richard Danne

**Thursdays
2:00 pm–3:30 pm**
1111 South Arroyo Parkway
5th floor, Graduate Studio
Pasadena, California

Neue Haas Grotesk

Designer: Max Miedinger (1910–1980)

1957: Basel, Switzerland

Modern Versions:

Linotype Neue Haas Grotesk, 2011

Before Helvetica was Helvetica, it was Neue Haas Grotesk. It was revised and named Helvetica (the Latin word for "Swiss") soon after its initial release. Linotype's hot metal typesetting required revisions and modifications to be made. These changes standardized much of the typeface and eliminated many of the more subtle refinements. As an example, the width of the bold and regular weights was required to be the same, leading to a more condensed bold weight. For the transition to phototypesetting, and then digital use, Helvetica was further modified.

In 2004, Christian Schwartz restored Neue Haas Grotesk for *The Guardian*. This digital version incorporates many of the features of Miedinger's original typeface, such as optical size variations, corrected obliques, alternate glyphs, and refined spacing.

SUGGESTIONS FOR SUCCESSFUL APPLICATION

➤➤ The difference between Helvetica and Neue Haas Grotesk is not recognizable by non-designers. However, Neue Hass Grotesk is a more refined typeface that can elevate ordinary Helvetica into an elegant neo-grotesque sans serif.

➤➤ Tighter letterspacing is more legible with upper- and lowercase Neue Haas Grotesk.

APPLICATIONS

Bloomberg Businessweek magazine
ArtCenter College of Design identity
Verizon logo
Zürich, Switzerland branding

SIMILAR

FF Bau
National
Akkurat
FF Real
Univers

OPPOSITE

ArtCenter Lecture Series
Sean Adams ~ 2016
Poster
Each season, Adams designs a poster for the design lecture series. ArtCenter's rigid, Swiss-style identity is offset with fictional images of the speakers. Often, a student will ask the speaker, "Is that really you?"

Zürich, Switzerland
Marcus Kraft ~ 2018
Identity system
The flexible wordmark provides the possibility of logo variations and interplay with the text. The layout and custom type, Zürich Haas Grotesk Round, refers to Swiss graphic design and typography in the 1960s.

18th Street Arts Center
Yuma Naito ~ 2017
Identity system
18th Street Arts Center is the largest artist residency program in Southern California. Naito created a proposal for a new visual identity inspired by the shape of the architecture and the idea of the artist residency.

Meetings and Conventions, Zürich, Switzerland.

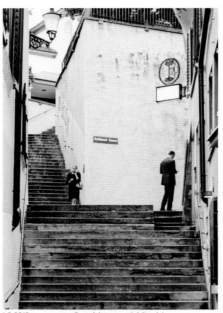

1.5.2018 – congress@zuerich.com #visitzurich
31.4.2019 +41 44 215 40 30 meeting.zuerich.com

Zürich Card, 2018.

Transport
+ Museums
+ Tours
+ Boat Cruises
+ Restaurants
+ Nightlife
+ Shopping
+ Family Offers
+ Wellness

= CHF 27 (24h)
= CHF 53 (72h)

10.12.2017 – Deutsch
8.12.2018 English

90
40
4

Culture
Mapping

Participate in 18th Street's Culture Mapping 90404 project! In collaboration with the Alliance for California Traditional Arts, we have trained community volunteers to document cultural resources, memories, and histories of the Pico neighborhood of Santa Monica by way of video interviews. These oral histories and cultural treasures will be collected in an interactive online map to debut in Spring of 2017.

4
40
90

18th

SCRATCHING THE BELLY OF THE BEAST • CUTTING EDGE MEDIA IN LOS ANGELES 1922–94

FEATURES
R
IES

filmforum

News Gothic

Designer: Morris Fuller Benton
(1872–1948)
1908: New York, New York, USA

Modern Versions:
Linotype News Gothic No. 2, 1958
ParaType News Gothic, 2006

Following the success of Franklin Gothic, Benton designed News Gothic for the American Type Founders (ATF). Marketing the typeface to newspapers and magazines, Morris designed News Gothic with condensed versions that worked for headlines. It is also slightly lighter in tone and better suited as a text typeface. For 50 years, News Gothic had a relatively small family of lighter weights, until, in 1958, John L. "Bud" Renshaw designed a bold version.

Today, News Gothic is produced by several digital type foundries and includes roman, condensed, extra condensed, italic, and bold fonts. With a warmer tone than Helvetica or Univers, News Gothic lends itself to cultural institutions, book design, and entertainment. It is the typeface for the opening text in the film *Star Wars* and the logo for the pop group ABBA.

SUGGESTIONS FOR SUCCESSFUL APPLICATION

➤➤ News Gothic is slightly condensed and works well where space is limited.

➤➤ News Gothic requires slightly open letterspacing, as tight kerning with the condensed form is difficult to read.

➤➤ Benton Sans has an extended family of fonts, adding additional features such as wide styles and extra-bold weights.

APPLICATIONS
Star Wars opening text
ABBA logo
Psycho title sequence

SIMILAR
Trade Gothic
Franklin Gothic
Benton Sans
Whitney

OPPOSITE
Feature Series
Sean Adams - 1993
Poster
A poster series for a film festival features an image of the silent film star Ramon Novarro. Relating to the festival theme of film in Los Angeles, the typography references the typographic language of safety glass on automobile windshields.

164

TM5-725

DEPARTMENT OF THE ARMY TECHNICAL MANUAL

RIGGING

HEADQUARTERS, DEPARTMENT OF THE ARMY
OCTOBER 1968

ARMYRG1068

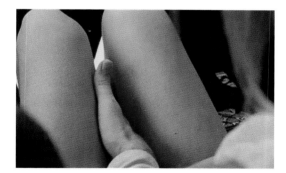

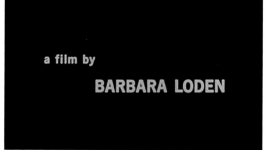

165

NEWS GOTHIC

» GROTESQUE SANS SERIF

OPPOSITE
Rigging
Department of the Army - 1968
Instruction manual
This manual for rigging is industrial and has
no extraneous design details. News Gothic
fulfills its role as a utilitarian typeface with
no decorative elements.

ABOVE
Wanda
Director: Barbara Loden - 1970
Film titles
Wanda is considered a feminist masterpiece.
The settings are dingy and the characters
unpredicatble, portraying authentic
emotions. The raw, plain titles set the tone
for the film.

SKIRTED MEN 7

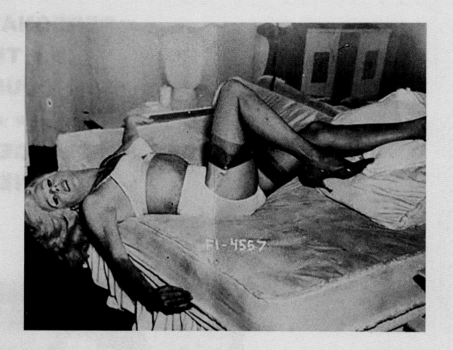

SKIRTED MEN
THE MONTHLY MAGAZINE
PHOTOS, FASHION, FICTION,
CORRESPONDENCE

Trade Gothic

Designer: Jackson Burke (1908–1975)
1948: San Francisco, California, USA

Modern Versions:
Adobe Trade Gothic, 2007
Linotype Trade Gothic, 1948

By the mid-twentieth century, several type foundries had released versions of Gothic typefaces. Linotype commissioned Jackson Burke to design Trade Gothic in 1948. Trade Gothic shares many of the same attributes as News and Franklin Gothic, from Linotype's competition, American Type Founders, but it has even less consistency as a family than either. Burke continued designing new weights and styles of Trade Gothic until 1960. Trade Gothic's lack of uniformity as a family is a primary reason for its success. In opposition to other more unified sans serif typefaces, its oddness give it a natural, quirky appeal. In the 1950s and 1960s, industrial materials and technical manuals were set in Trade Gothic. By the 1990s, and the rise of postmodernism, it was rediscovered as a typeface for educational, cultural, and architectural materials.

SUGGESTIONS FOR APPLICATIONS
➤➤ Trade Gothic Bold is more condensed than Trade Gothic Bold #2. Use #2 when paired with Trade Gothic roman.
➤➤ Trade Gothic Condensed #18 and Bold Condensed #20 are especially successful as letterspaced capitals.

APPLICATIONS
Design Within Reach catalogues
Levi Strauss packaging
"Go!", Dexter Gordon album cover

SIMILAR
Franklin Gothic
News Gothic
DIN
Heroic

OPPOSITE
Skirted Men
Unknown - 1956
Booklet
The restrictive attitudes of the 1950s forced any communication deemed "abnormal" underground. Cheaply printed and distributed in secret, this publication was probably designed by a printer. The industrial Trade Gothic typeface and bad-quality black-and-white image betray the subversive and secretive nature of the booklet.

BELOW AND OPPOSITE
Building Sex
Sean Adams: AdamsMorioka - 1995
Book
Building Sex, by noted author Aaron Betsky, is
about gender in architecture. The bold cover
addressed the need to stand out in an architectural
and academic section of a bookstore.

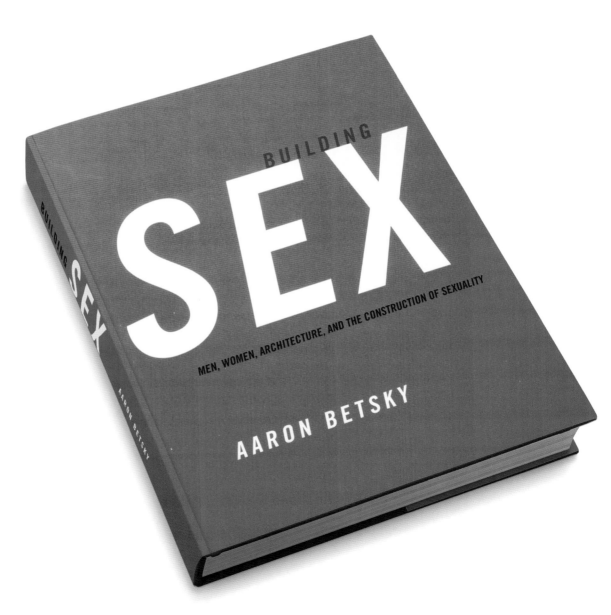

BUILDING **SEX**

Men, Women, Architecture, and the Construction of Sexuality

PREVIOUS BOOKS BY AARON BETSKY

VIOLATED PERFECTION: ARCHITECTURE AND THE FRAGMENTATION OF THE MODERN

JAMES GAMBLE ROGERS AND THE ARCHITECTURE OF PRAGMATISM

AARON BETSKY

WILLIAM MORROW AND COMPANY, INC. NEW YORK

5

THE DISCREET PLACES OF THE BOURGEOISIE

THEODORE DREISER'S 1900 NOVEL *SISTER CARRIE* traces the trajectory of a country girl as she enters the city. Drawn to Chicago by the promise of "making something of herself," she finds herself lost in a labyrinth, a place that is completely alien to her as a woman and a human being:

Figure 7.1: Daniel Burnham, *Civic Square*, from Plan for Chicago, 1908

> Into this important commercial region, the timid Carrie went. She walked east along Van Buren Street through a region of lessening importance, until it deteriorated into a mass of shanties and coal-yards, and finally verged upon the river. She walked bravely forward, led by an honest desire to find employment and delayed at every step by the interest of the unfolding scene, and a sense of helplessness amid so much evidence of power and force which she did not understand. These vast buildings, what were they? These strange energies and huge interests, for what purposes were they here? When the yards of some huge stone corporation came into view, filled with spur tracks and flat cars, transpierced by docks from the river, and traversed overhead by immense trundling cranes of wood and steel, it lost all significance in her little world.

She finds work in a factory, where she is hemmed in completely by the machinery of production. There is no place for her in the city, however, exciting it might be. While she is lost in this world of aches and pains made real, the man who will seduce her, both "ruining" her and liberating her to become a woman of her own, is at home in the environment his wife has created.

> A lovely home atmosphere is one of the flowers of the world, than which there is nothing more tender, nothing more delicate, nothing more calculated to make strong and trust the natures cradled and nourished within it. Those who have never experienced such a beneficent influence will not understand wherefore the tear springs glistening to the eyelids at some strange breath of lovely music. The mystic chords which bind and thrill the heart of the nation, they will never know. Hurstwood's residence could scarcely be said to be infused with this home spirit. It lacked that toleration and regard without which the home is nothing. There was fine furniture, arranged as soothingly as the artistic perception of the occupants warranted. There were soft rugs, rich upholstered chairs and divans, a grand piano, a marble carving of some unknown Venus by some unknown artist, and a number of small bronzes gathered from heaven knows where, but generally sold by the large furniture houses along with everything else which goes to make the perfectly appointed house.

> • 130 •

In this comfortable and isolated world of the domestic suburban interior, the woman tries to create a place of culture and belonging for her philandering husband and her spoiled children by gathering all the myriad consumer goods the city has to offer. It is a huly place, a place where she creates a world of connections that seeks to weave its magic spell behind the forbidding facades of the metropolis. Carrie's great achievement is to create a facsimile of this, itself artificial, world. She can do that only because she is installed within it by her seducer, who rents an apartment for her:

BELOW
Tidningshuset by Pontus
Bold Sacndinavia- 2011
Restaurant identity
Tidningshuset is a restaurant, deli, and bakery
in the Stockholm building owned by Sweden's
largest newspaper. The logotype references
both traditional and contemporary typography
of the newspaper industry.

FOLLOWING
Golden Days Before They End
Roland Hörmann: Phospho - 2016
Book
Klaus Pichler and Clemens Marschall
photographed and wrote about the last of a
dying generation drinking in obscure bars.
Hörmann's off-the-shelf typography and plain
wood background speak to the locations.

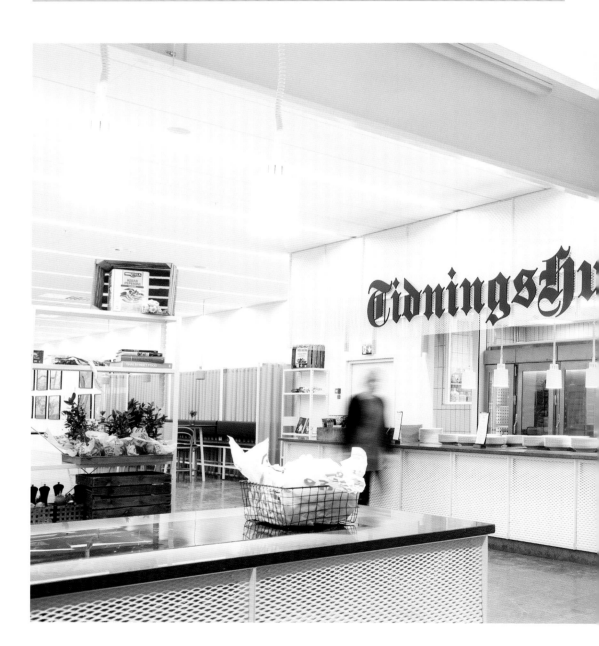

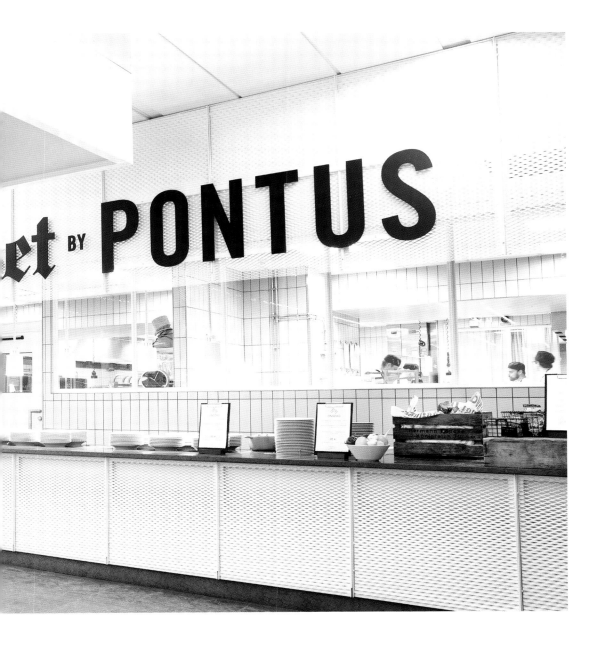

Klaus Pichler
Clemens Marschall

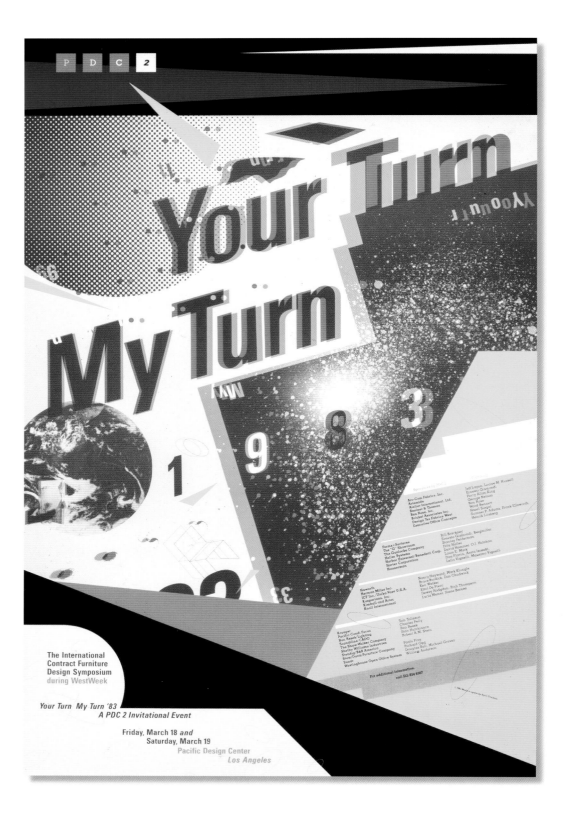

Univers

Designer: Adrian Frutiger (1928—2015)
1957: Paris, France

Modern Versions:
Linotype Univers, 1997
Univers Next, 2010

By the mid-1950s, phototypesetting had begun to replace metal type. Rather than printing ink on paper through an impression, phototype used a photographic technique that allowed for more refinement. A photographic disk replaced drawers of metal type in various sizes, so the process lost multiple versions of a typeface, each specific to its size. Adrian Frutiger designed Univers with extremely refined letterforms to compensate for the changes brought about by the new process. He also designed the typeface as a complete and unified family. The consistent grouping was exceptionally successful for designers working with Swiss typography looking for a neutral and reductive typeface. Rather than mixing typefaces or working with visually incoherent styles, a designer could use only Univers for every solution.

SUGGESTIONS FOR SUCCESSFUL APPLICATION

➻ Univers was the first typeface to employ a numeric code for weights and styles. Adrian Frutiger later applied the same coding system to Frutiger.

Univers Numerical Code

	3	4	5	6	7	8	9
Weight	Thin	Light	Regular	Semi-Bold	Bold	Heavy	Black
Style	Extended	none	Roman	Italic	Condensed Italic	Condensed	Ultra Condensed

SUCCESSFUL APPLICATIONS
Swiss International Air Lines identity
Deutsche Bank branding
ArtCenter College of Design identity
1972 Summer Olympics, Munich identity
1976 Summer Olympics, Montreal identity
1984 Summer Olympics, Los Angeles identity

SIMILAR
Helvetica
Forma
Unica
Imago
National

OPPOSITE
Your Turn My Turn (3-D) PDC2
April Greiman: Made in Space ~ 1983
Poster
For an event at the Pacific Design Center, Greiman creates the effect of three-dimensional typography in space. Rather than simply suggesting 3-D with scale and placement, Greiman additionally printed the poster to be viewed with 3-D glasses.

BELOW
Design Diaries: Creative Process in Graphic Design
Lucienne Roberts ~ 2010
Book

OPPOSITE AND FOLLOWING
Criss + Cross Design from Switzerland
Jin & Park ~ 2011
Exhibition catalogue

Design Diaries examine the elements of the creative process through a series of in-depth studies of a range of graphic design projects from the start of the process to completion.

The name of the traveling exhibition of Swiss design refers to the Swiss flag. The Korean edition maintains the Swiss grid rigor and elegantly adds a second language.

Criss+Cross 1860 스위스 디자인

Design 2012 크리스+크로스
from
Switzerland

by
Ariana Pradal
Köbi Gantenbein

Translated by
Chi Ho In

아리아나 프라달
쾨비 간텐바인
지음

인치호
옮김

안그라픽스의 책

스위스 디자인 여행
박우혁 지음 384쪽 18,000원
타이포그래피디자이너 박우혁이 풀어내는 진짜 스위스 디자인.
스위스 바젤디자인대학에서 2년간 머무르면서 보고 듣고 느꼈던 모든 것을
그만의 섬세한 틴 글과 사진으로 담아냈다. 디자인대학의 타이포그래피 강의,
볼프강 바인가르트와의 만남, 스위스 디자인의 성지들과 타이포그래피 작품들,
네 가지 언어로 장식된 스위스 화폐, 카니발을 맞아 거리를 가득 메운
빨간 십자가 등 스위스 디자인의 힘이 어디에서 오는지 알 수 있다.

동방여행
르 코르뷔지에 지음 최정수 옮김 316쪽 17,000원
20대의 르 코르뷔지에와 만나다. 눈에 보이는, 지각에 작용되는, 감성에 영향을
주는 모든 사물의 움직임을 섬세하게 재집힌 엄김한 추억이자 글로 기록한
시간의 이미지들. 이 책은 르 코르뷔지에가 예술가로, 건축가로 성장하는 데
결정적인 역할을 한 기간을 기록한 중요하고 의미심장한 자료일 것이다.

타이포그래피 투데이
헬무트 슈미트 지음 안상수 옮김 184쪽 25,000원
타이포그래피는 들려야 한다.
타이포그래피는 느껴져야 한다.
타이포그래피는 체험되어야 한다.
타이포그래피의 도전이 이루어지고 타이포그래피가 세련되어 강탄 시기,
곧 20세기의 타이포그래피를 기념하는 책이다. 「타이포그래피 투데이」, 한국어판은
새 판형에 맞추어 레이아웃을 고치고 한국 디자이너들의 작품을 추가했다.

슈퍼노멀
후카사와 나오토, 재스퍼 모리슨 지음 박영춘 옮김 136쪽 20,000원
만약 디자인이 언제가 '웹(normal 한 것이 된다면, '멋지(super 않을까?
수많은 디자인 작품은 왜 평범함을 상실하는가? 평범함이 사라지면 그 빈자리를
무엇으로 대체할 것인가? 훌륭한 제품을 만드는 것은 무엇이며, 왜 그 제품들은
시간이 갑수록 가치를 받게 되는가? 슈퍼노멀을 여러 의미로 성비할 수 있다.
물론 개개인의 가치관에 따라 그 정의 역시 조금씩 달라질 것이다.

밀곱 개의 보물 상자 안에 포장된
중유럽의 한 작고 부유한 나라에 관한 이야기

스위스 예술위원회 프로헬베티아의 생동감 있고 적극적인
순회 전시 〈Criss+Cross〉는 보고 연구할 만한 놀라운 것들로
가득하다. 이 전시는 집안용품부터 패션 액세서리까지,
튼튼한 산악용 장화에서 컴퓨터 마우스까지 별도의 섹션으로
구분하여 각 카테고리에 옛것과 새것을 나란히 보여 준다.
〈Criss+Cross〉 전시의 여정은 지속될 것이며,
새로운 디자인 담론과 화젯거리들이 생겨날 것이다.
과연 그것들이 전시되는 디자인 작품들에 어떠한 영향을 줄지
지켜보는 것 또한 흥미로울 것이다.

The Story about a Small, Wealthy Country
in the Middle of Europe with the Seven Treasure Chests

As a spirited and active touring exhibition with
the support of the Swiss Arts Council Pro Helvetia,
Criss+Cross is full of astonishing things to see and
study. Divided into sections that range from household
goods to fashionable accessories, from robust mountain
boots to the computer mouse, the exhibition presents
old and new side-by-side in each category. The journey
of Criss+Cross will continue, giving rise to new stories
and dialogues. It will be exciting to see how they impact
the designs in this exhibition.

롱셀러	Longsellers
작고 아름답다	Small+Beautiful
아주 작은 조력자들	Tiny Helpers
산 위로	Up to the Mountains
유벌+젊음	Hip+Young
시각적 진술 제시	A Visual Statement
직물과 패션	Textile+Fashion

9788970595887 03600
안그라픽스 www.agbook.co.kr
ISBN 978.89.7059.588.7 ₩ 23,000

안그라픽스의 책

스위스 디자인 여행
박우혁 지음 384쪽 18,000원
타이포그래피디자이너 박우혁이 풀어내는 진짜 스위스 디자인.
스위스 바젤디자인대학에서 2년간 머무르면서 보고 듣고 느꼈던 모든 것을
그만의 섬세한 틴 글과 사진으로 담아냈다. 디자인대학의 타이포그래피 강의,
볼프강 바인가르트와의 만남, 스위스 디자인의 성지들과 타이포그래피 작품들,
네 가지 언어로 장식된 스위스 화폐, 카니발을 맞아 거리를 가득 메운
빨간 십자가 등 스위스 디자인의 힘이 어디에서 오는지 알 수 있다.

동방여행
르 코르뷔지에 지음 최정수 옮김 316쪽 17,000원

밀곱 개의 보물 상자 안에 포장된
중유럽의 한 작고 부유한 나라에 관한 이야기

스위스 예술위원회 프로헬베티아의 생동감 있고 적극적인
순회 전시 〈Criss+Cross〉는 보고 연구할 만한 놀라운 것들로
가득하다. 이 전시는 집안용품부터 패션 액세서리까지,
튼튼한 산악용 장화에서 컴퓨터 마우스까지 별도의 섹션으로
구분하여 각 카테고리에 옛것과 새것을 나란히 보여 준다.
〈Criss+Cross〉 전시의 여정은 지속될 것이며,
새로운 디자인 담론과 화젯거리들이 생겨날 것이다.
과연 그것들이 전시되는 디자인 작품들에 어떠한 영향을 줄지
지켜보는 것 또한 흥미로울 것이다.

The Story about a Small, Wealthy Country
in the Middle of Europe with the Seven Treasure Chests

As a spirited and active touring exhibition with
the support of the Swiss Arts Council Pro Helvetia,
Criss+Cross is full of astonishing things to see and
study. Divided into sections that range from household
goods to fashionable accessories, from robust mountain
boots to the computer mouse, the exhibition presents
old and new side-by-side in each category. The journey
of Criss+Cross will continue, giving rise to new stories
and dialogues. It will be exciting to see how they impact
the designs in this exhibition.

롱셀러	Longsellers
작고 아름답다	Small+Beautiful
아주 작은 조력자들	Tiny Helpers
산 위로	Up to the Mountains
유벌+젊음	Hip+Young
시각적 진술 제시	A Visual Statement
직물과 패션	Textile+Fashion

9788970595887 03600
안그라픽스
ISBN 978.89.7059.588.7 ₩ 23,000

Criss+Cross 1860

스위스 디자인

Design from Switzerland 2012

크리스+크로스

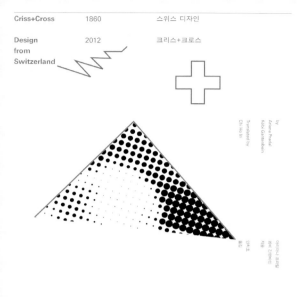

by
Ariana Pradal
Köbi Gantenbein
Translated by
Chi Ho In

아리아나 프라달
쾨비 간텐바인
지음

인치호
옮김

아르고나인

아리아나 프라달 Ariana Pradal

취리히예술디자인학교(현 취리히예술대학)에서 산업디자인을 공부했다. 디자인·건축 저널 〈호흐파르테레〉에서 2년 동안 일하면서 스위스 저널리즘학교를 다녔으며, 전시를 디자인하고 단행본 작업 및 강의를 했다. 6개월간 뉴욕에서 비즈니스와 외교 분야의 경험과 인식을 받고 스위스로 돌아온 다음 3년간 건축저널 〈베르크, 바우엔 + 보넨〉에서 일했다. 현재 디자인과 건축을 비롯한 관련 분야에서 저널리스트 겸 큐레이터로 일하며, 다양한 기관에 자문을 제공하고 있다.

Ariana Pradal studied industrial design at the School of Art and Design Zurich, (now the Zurich University of the Arts, ZHdK). She completed a two-year traineeship with Hochparterre, a Swiss journal of design and architecture, while at the same time taking courses at the Swiss School of Journalism in Lucerne. During her time at Hochparterre she wrote articles, designed exhibitions, worked on books, and gave lectures. After spending six months in New York gaining experience in business and diplomacy, she returned to Switzerland where she spent three years working part-time for the architectural journal Werk, Bauen und Wohnen. Today she works as a journalist and curator in the areas of design, architecture and related disciplines, while advising various institutions on a range of matters.

쾨비 간텐바인 Köbi Gantenbein

취리히대학교에서 사회학을 전공하고 그라우뷘덴 주의 여행 담당 기관에서 사용되는 그래픽 예술에 관한 논문을 썼다. 졸업 후 〈뷘트너 차이퉁〉에 근무하며 저널리스트 수업을 받았다. 취리히예술디자인학교에서 2002년까지 15년간 부교수로 근무했다. 1988년에는 베네딕트 로더러와 함께 디자인·건축 저널 〈호흐파르테레〉를 창간해 20여 명의 직원을 둔 회사로 성장시켰다. 현재 단행본과 카탈로그 출간 및 전시 기획, 강의 등 다양한 분야에서 활동하고 있다.

Köbi Gantenbein studied sociology at the University of Zurich and completed his studies with a thesis on the graphic art used by the tourism branch in the Swiss canton of Graubünden. After university he worked for Bündner Zeitung and was trained as a journalist. Up until 2002, he spent 15 years as associate professor at the School of Art and Design Zurich. In 1988, he and Benedikt Loderer launched the architecture and design journal Hochparterre, which now employs 20 people. Today, he publishes books and catalogues, curates exhibitions, and delivers speeches.

올긴이·인치호 Chi Ho In

홍익대학교 도시계획학과를 졸업하고 미국 Art Center College of Design에서 제품디자인 학사와 석사를 마치고 서울대학교 환경조경학으로 환경조경학의 박사학위를 받았다. 1993년에서 2010년까지 홍익대학교 산업디자인학과의 교수와 한국공공디자인학회 부회장을 역임했다. 현재는 고려대학교 디자인조형학부의 교수로 재직 중이며 한국디자인학회의 부회장을 맡고 있다.

After graduating from Hongik University's Department of Urban Design, Chi Ho In received a bachelor's degree and a master's degree in product design at Art Center College of Design in Pasadena, California. He then earned a Ph.D. in landscape architecture at Seoul National University's Graduate School of Environmental Studies. From 1993 to 2010, he served as a professor at Hongik University's Department of Industrial Design and vice president of the Korean Society of Public Design. Currently, he is a professor at Korea University's School of Art & Design, as well as vice president of the Korean Society of Design Science.

Criss+Cross 1860

스위스 디자인

Design from Switzerland 2012

크리스+크로스

by
Ariana Pradal
Köbi Gantenbein
Translated by
Chi Ho In

아리아나 프라달
쾨비 간텐바인
지음

인치호
옮김

아르고나인

아리아나 프라달 Ariana Pradal

취리히예술디자인학교(현 취리히예술대학)에서 산업디자인을 공부했다. 디자인·건축 저널 〈호흐파르테레〉에서 2년 동안 일하면서 스위스 저널리즘학교를 다녔으며, 전시를 디자인하고 단행본 작업 및 강의를 했다. 6개월간 뉴욕에서 비즈니스와 외교 분야의 경험과 인식을 받고 스위스로 돌아온 다음 3년간 건축저널 〈베르크, 바우엔 + 보넨〉에서 일했다. 현재 디자인과 건축을 비롯한 관련 분야에서 저널리스트 겸 큐레이터로 일하며, 다양한 기관에 자문을 제공하고 있다.

Ariana Pradal studied industrial design at the School of Art and Design Zurich, (now the Zurich University of the Arts, ZHdK). She completed a two-year traineeship with Hochparterre, a Swiss journal of design and architecture, while at the same time taking courses at the Swiss School of Journalism in Lucerne. During her time at Hochparterre she wrote articles, designed exhibitions, worked on books, and gave lectures. After spending six months in New York gaining experience in business and diplomacy, she returned to Switzerland where she spent three years working part-time for the architectural journal Werk, Bauen und Wohnen. Today she works as a journalist and curator in the areas of design, architecture and related disciplines, while advising various institutions on a range of matters.

AKZIDENZ GROTESK REGULAR

ABCDEFGHIJKLMNOPQRSTUVWXYZ
abcdefghijklmnopqrstvwxyz
1234567890&?$£

CHARACTERISTICS FOR IDENTIFICATION

square apex wide lobe double story "a"

ARQGag

45 degree angle tail wide bar and deep spur hook tail, not a bowl

ITC AVANT GARDE BOOK

ABCDEFGHIJKLMNOPQRSTUVWXYZ
abcdefghijklmnopqrstvwxyz
1234567890&?$£

CHARACTERISTICS FOR IDENTIFICATION

square apex geometric circle horizontal terminal single story geometric circle

ARQGag

leg doesn't connect swash tail with counter no spur high descender

AVENIR ROMAN

ABCDEFGHIJKLMNOPQRSTUVWXYZ
abcdefghijklmnopqrstvwxyz
1234567890&?$£

CHARACTERISTICS FOR IDENTIFICATION

square apex *geometric circle* *double story "a"* *geometric circle*

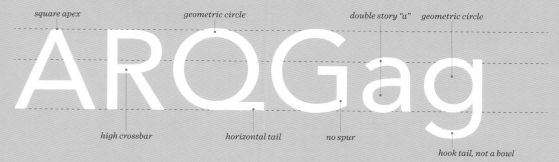

high crossbar *horizontal tail* *no spur*

hook tail, not a bowl

EF REAL HEAD REGULAR

ABCDEFGHIJKLMNOPQRSTUVWXYZ
abcdefghijklmnopqrstvwxyz
1234567890&?$£

CHARACTERISTICS FOR IDENTIFICATION

notched apex *simple counter shape* *horizontal terminal* *double story "a"* *vertical ear end*

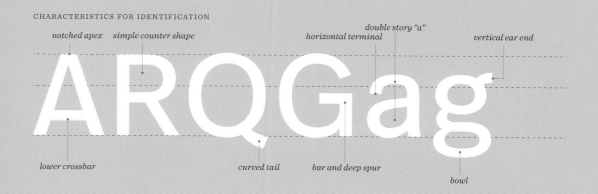

lower crossbar *curved tail* *bar and deep spur*

bowl

ITC FRANKLIN GOTHIC ROMAN

ABCDEFGHIJKLMNOPQRSTUVWXYZ
abcdefghijklmnopqrstvwxyz
1234567890&?$£

CHARACTERISTICS FOR IDENTIFICATION

double story "a"

square apex

ARQGag

thin, thick strokes

condensed width

hook tail

bar and notched spur

bowl

FRUTIGER 55

ABCDEFGHIJKLMNOPQRSTUVWXYZ
abcdefghijklmnopqrstvwxyz
1234567890&?$£

CHARACTERISTICS FOR IDENTIFICATION

double story "a" thick and thin strokes

square apex

ARQGag

curved connection

horizontal terminal on tail

narrow bar and no spur

hook

FUTURA BOOK

ABCDEFGHIJKLMNOPQRSTUVWXYZ
abcdefghijklmnopqrstvwxyz
1234567890&?$£

CHARACTERISTICS FOR IDENTIFICATION

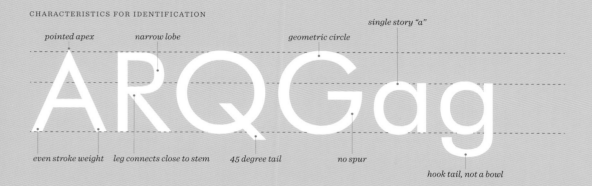

pointed apex *narrow lobe* *geometric circle* *single story "a"*

even stroke weight *leg connects close to stem* *45 degree tail* *no spur* *hook tail, not a bowl*

GILL SANS

ABCDEFGHIJKLMNOPQRSTUVWXYZ
abcdefghijklmnopqrstvwxyz
1234567890&?$£

CHARACTERISTICS FOR IDENTIFICATION

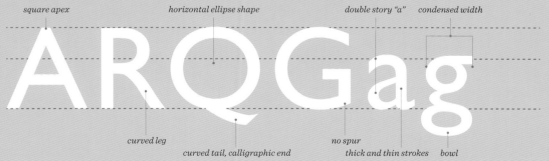

square apex *horizontal ellipse shape* *double story "a"* *condensed width*

curved leg *curved tail, calligraphic end* *no spur* *thick and thin strokes* *bowl*

HTF GOTHAM

ABCDEFGHIJKLMNOPQRSTUVWXYZ
abcdefghijklmnopqrstvwxyz
1234567890&?$£

CHARACTERISTICS FOR IDENTIFICATION

double story "a"

square apex wide lobe geometric circle

ARQGag

even stroke weight leg connects far from stem tail on right side no spur

hook tail, not a bowl

GRAFIL REGULAR

ABCDEFGHIJKLMNOPQRSTUVWXYZ
abcdefghijklmnopqrstvwxyz
1234567890&?$£

CHARACTERISTICS FOR IDENTIFICATION

square apex large counter

ARQGag

condensed width vertical stress no spur horizontal connection

ABCDEFGHIJKLMNOPQRSTUVWXYZ
abcdefghijklmnopqrstvwxyz
1234567890&?$£

CHARACTERISTICS FOR IDENTIFICATION

square apex *lobe same width as leg* *horizontal terminal* *double story "a"*

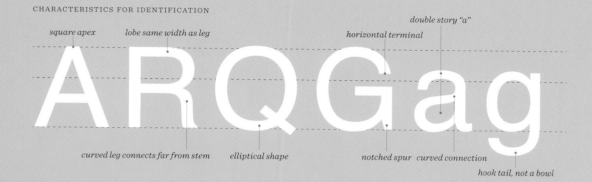

curved leg connects far from stem *elliptical shape* *notched spur* *curved connection* *hook tail, not a bowl*

ABCDEFGHIJKLMNOPQRSTUVWXYZ
abcdefghijklmnopqrstvwxyz
1234567890&?$£

CHARACTERISTICS FOR IDENTIFICATION

square apex *tablet shape* *double story "a"* *upturned ear*

ARQGag

curved leg *curved tail* *notched spur* *bowl* *thick and thin strokes*

NEUE HAAS GROTESK ROMAN

ABCDEFGHIJKLMNOPQRSTUVWXYZ
abcdefghijklmnopqrstvwxyz
1234567890&?$£

CHARACTERISTICS FOR IDENTIFICATION

double story "a" wider than Helvetica

square apex lobe same width as leg horizontal terminal

ARQGag

curved leg connects far from stem elliptical shape notched spur curved terminal

hook tail, not a bowl

NEWS GOTHIC MEDIUM

ABCDEFGHIJKLMNOPQRSTUVWXYZ
abcdefghijklmnopqrstvwxyz
1234567890&?$£

CHARACTERISTICS FOR IDENTIFICATION

square apex round counter

ARQGag

condensed width centered tail vertical spur simple connection

TRADE GOTHIC REGULAR

ABCDEFGHIJKLMNOPQRSTUVWXYZ
abcdefghijklmnopqrstvwxyz
1234567890&?$£

CHARACTERISTICS FOR IDENTIFICATION

square apex lobe same width as leg angled terminal double story "a"

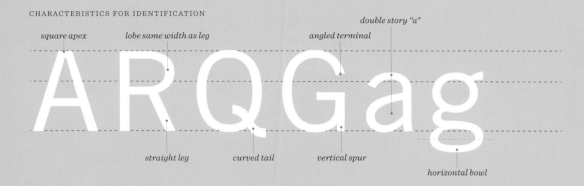

straight leg curved tail vertical spur horizontal bowl

UNIVERS 55

ABCDEFGHIJKLMNOPQRSTUVWXYZ
abcdefghijklmnopqrstvwxyz
1234567890&?$£

CHARACTERISTICS FOR IDENTIFICATION

square apex elliptical shape double story "a" no ear

ARQGag

curved leg horizontal tail no spur hook

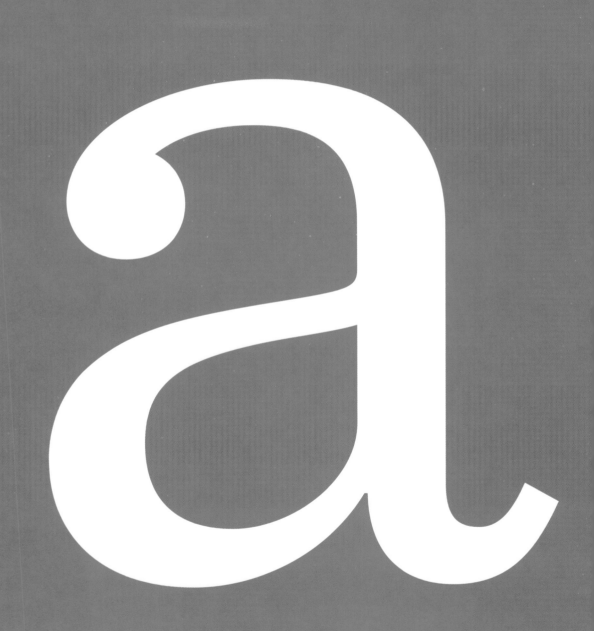

Slab Serif

or Egyptian

189

Archer

Designers:
Jonathan Hoefler (b. 1970)
Tobias Frere-Jones (b. 1970)
2001: New York, New York, USA

Modern Versions:
HTF Archer, 2003

Initially designed for *Martha Stewart Living* magazine, Archer combines the geometry of a sans serif and the legibility of a serif typeface. Hoefler and Frere-Jones designed multiple weights and styles, adding a broad suite of typographic elements for recipes, charts, and diagrams. Archer is officially a slab serif typeface but borrows forms from typewriter typefaces to provide a sense of practicality and ease of use. The team added "ball terminals" to lowercase letters such as "a." The capital letters also incorporate these features, creating a plain-spoken and less formal spirit.

Few slab serif typefaces are successful as both headline and text-weight fonts. However, Archer's refined form and multiple weights are legible at small sizes and work equally well on a large scale. Archer also translates well to a screen environment. The friendly attitude and workhorse range are two of several reasons for the typeface's enormous success.

SUGGESTIONS FOR SUCCESSFUL APPLICATION

➤ Archer includes multiple numerics, true fractions, and tabular numerals. These are exceptionally well suited for information design, tables, and mathematical data.
➤ Archer's extensive suite of letterforms includes symbols for 140 languages. This is a critical consideration when working with multiple languages.

APPLICATIONS
Martha Stewart Living magazine
Wells Fargo branding

SIMILAR
Clarendon
Rockwell
Neutraface Slab Text
PMN Caecilia 55

OPPOSITE
Thorsteinn
Thorleifur Gunnar Gíslason, Hlynur Ingólfsson, Geir Olafsson - 2015
Packaging
For a proposal for a microbrewery, the design team chose a traditional Icelandic name that could be loosely translated as "thirsty one." The concept is to maintain the Archer typography, and ask 10 designers to design 10 different bottles.

BELOW
The Color Design Workbook
Sean Adams · 2015
Book
The content of the book is organized with
two weights and three sizes of Archer. The
minimal typographic palette maintains
unity with disparate imagery.

Contents

Clarendon

Designer: Robert Besley (1794–1876)

1845: London, UK

Modern Versions:

Linotype Clarendon, 1953

URW Clarendon, 2006

Clarendon is an early Egyptian, or slab serif, typeface. These typefaces first appeared in Victorian England, and the term "Egyptian" is due to the popularity at the time of all things hailing from Egypt. Early Egyptian typefaces were carved in wood for large headlines. In 1845, Robert Besley designed Clarendon for use in headlines and large text sizes. Typically, Egyptian typefaces are broad and extended for headlines. Besley condensed the letterforms slightly to read legibly as text copy. Besley also added roman and bold weights. The bold weight has a proper visual alignment with the roman. This was a rarity at the time for text typefaces.

By the 1920s, Clarendon was considered old-fashioned. Designers and printers preferred the sleek geometric sans serif typefaces from Europe, such as Futura. By the 1950s, however, art directors were turning once again to Clarendon as a friendlier alternative.

SUGGESTIONS FOR SUCCESSFUL APPLICATION

➻ While Clarendon was designed to work as text, it is too wide and tiresome to read in large quantities. Sentinel is a good alternative.

➻ Clarendon's imperfections provide character, making it perfect for projects that need extra "personality."

APPLICATIONS

U.S. National Parks signage

Sony logo

Vertigo title sequence

SIMILAR

Ionic

Rockwell

Craw Clarendon

Archer

Giza

OPPOSITE

Stratus Screw Red 06

Michael Vanderbyl - 2006

Packaging

As a comment on the screw top of the wine bottle, Vanderbyl uses a simple black screw illustration. This combines with minimal typography typeset in Clarendon for the name and year of the product.

Frühling 2015 / Nr. 54

fluter.

Magazin der Bundeszentrale für politische Bildung

Thema: Russland

THE KINGSTON TRIO

15

OPPOSITE
Fluter
Jan Spading: ZMYK - 2015
Magazine

Fluter magazine is published every three months. Each issue is devoted to a single theme, ranging from the body to Russia.

ABOVE
The Kingston Trio
Tony Palladino - 1959
Magazine

A hole runs through the center of this magazine about new music in 1959, such as the Kingston Trio. A vinyl album was included, hence the hole.

FOLLOWING
Reflection
P-06 Atelier - 2011
Magazine

For the exhibition *A Assembleia Constituinte e a Constituição de 1911*, P-06 designed an installation covered by mirrors to present the exhibition title and information, while reflecting the surrounding environment.

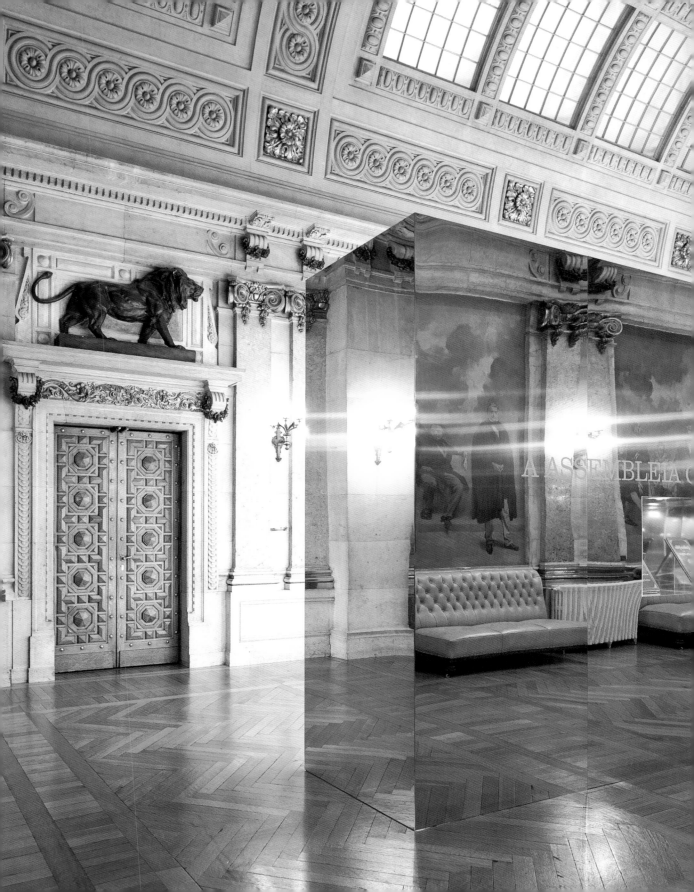

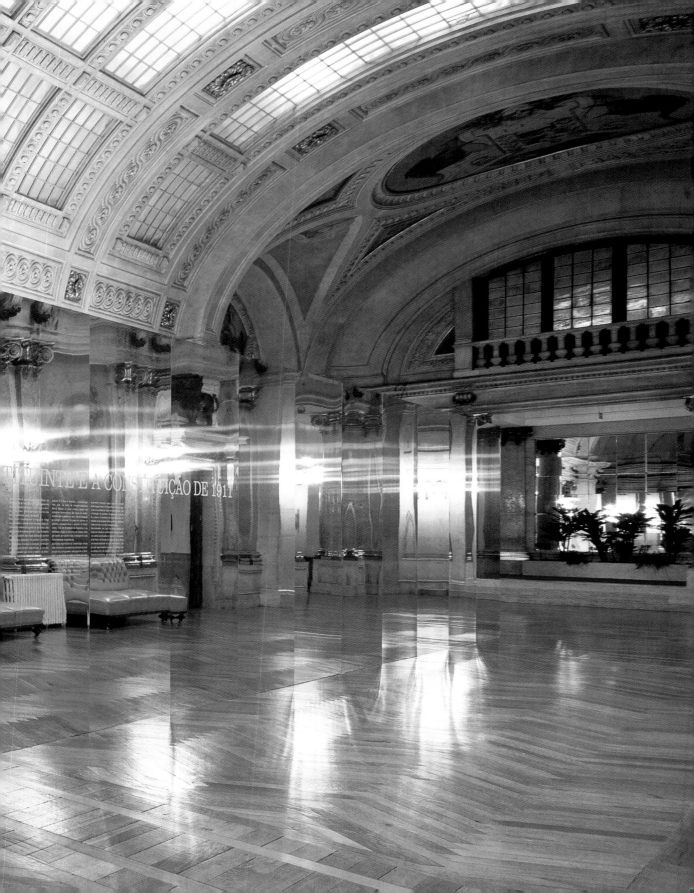

doctors and patients alike.

POWEREASE™ could allow surgeons to	Spend **51**% less time tapping the pedicle	Spend **55**% less time placing screws	See **38**% less wobble placing screws

"The POWEREASE™ System reduces surgeon's fatigue associated with repetitive hand motion and enhances surgeon control in complex reconstructions of the spine."

Doug King
Senior Vice President, Medtronic Spinal

MORE: IDEO.COM

Designing Better Instruments for Orthopedic Surgeons

EXPERTISE:
New Ventures Brand
Experience **Product**
Organization Digital

CLIENT:
Medtronic

Few things are worse than back pain. It can turn the simplest act into an unholy agony. Often surgery is the only option. But going under general anesthesia to lay bare the backbone of your being is a daunting prospect.

And not just for patients. Spinal surgery requires orthopedic surgeons to perform delicate procedures—drilling, tapping, and driving specialized implants into bone. Over time, those repetitive movements strain their ability to be effective.

Medtronic knew that better tools could make a real difference, so they partnered with IDEO to build next-generation powered surgical instruments that improve the comfort, control, and speed of surgeons and their staff.

Integrating human-centered research and cutting-edge design and engineering, the team launched The Spinal POWEREASE™ Surgical Instrument System.

POWEREASE™ minimizes the forces transmitted to the patient compared with previous techniques—allowing surgeons' work to be more fully realized as intended. Moreover, the FDA-approved instruments allow surgeons to work faster, ultimately benefiting doctors and patients alike.

POWEREASE™	Spend **51**%	Spend **55**%	See **38**%

Sentinel

Designer: Jonathan Hoefler (b. 1970)
2009: New York, New York, USA

Modern Versions:
HTF Sentinel, 2009

While Clarendon works well as a headline or subhead typeface, it is too broad and uniform to be legible as text. As a family, Clarendon is also limited: there is no italic, only three weights, and limited alternative characters. In 2009, Jonathan Hoefler addressed these issues with Sentinel. He maintained many of Clarendon's favorite features—the ball terminals, softer serif connections, and decorative numerals—but he refined the letterforms to be more condensed and suitable for text use. He also added the long-missing italics, multiple weights, and a set of old style numerals. Sentinel has a wealth of ligatures, glyphs, and alternative characters for most languages. It also exists as a web typeface, modified for screen usage.

SUGGESTIONS FOR SUCCESSFUL APPLICATION

➼ This book is typeset entirely in Sentinel. It works well at any scale. Old style numerals are available as an open-type option.

➼ Sentinel italic is weighted to work with the roman in the text. There is no need to enlarge the italic words slightly.

APPLICATIONS
Annenberg Community Beach House signage
De:Bug magazine

SIMILAR
Clarendon
Egyptienne

OPPOSITE
IDEO Snapshots
Eric Heiman, Adam Brodsley, Bryan Bindloss, Daniel Surgeon:
Volume - 2014
Digital and print cards
IDEO's Snapshots series is an ongoing promotional collection of the firm's recent projects, given primarily to potential clients.

Doors Open at 7:30pm
Conversation at 8:00pm
Band at 10:00pm
Hosted by Justin Veach

Little

$15 General Admission/$12 Young Literati and Library Associates
For more information and the latest news on special guests
www.thisisyourlibrary.org

03.03.11

Library
Foundation
of Los Angeles

DIDION

Wednesday, November 16
7:00 p.m.
ALOUD at Vibiana
The White Album to Blue Nights:
An Evening with Joan Didion

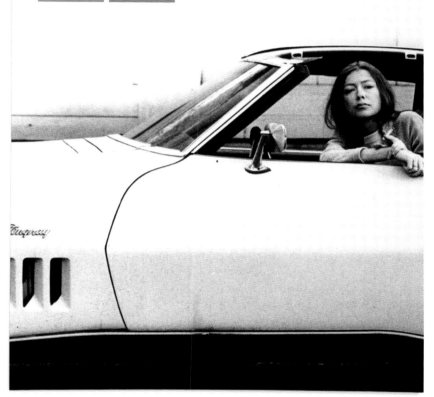

OPPOSITE AND ABOVE
LFLA Aloud
Sean Adams: AdamsMorioka · 2010
Poster series
The Library Foundation of Los Angeles hosts
lectures by a variety of guests. These posters
promote events with author Joan Didion and
photographer Blake Little. Sentinel is the only
typeface in the identity system.

HOEFLER ARCHER MEDIUM

ABCDEFGHIJKLMNOPQRSTUVWXYZ
abcdefghijklmnopqrstvwxyz
1234567890&?$£

CHARACTERISTICS FOR IDENTIFICATION

crossbar apex *square serifs* *ball terminals* *double story "a"* *square ear*

ARQGag

horizontal terminal *swash tail* *horizontal bar and vertical spur*

hook tail, not a bowl

ADOBE CLARENDON ROMAN

ABCDEFGHIJKLMNOPQRSTUVWXYZ
abcdefghijklmnopqrstvwxyz
1234567890&?$£

CHARACTERISTICS FOR IDENTIFICATION

square apex *thick and thin strokes* *notched terminal* *ball teardrop* *ball ear*

ARQGag

curved connection *hook leg* *wave tail* *notched spur*

bowl

H&FJ SENTINEL BOOK

ABCDEFGHIJKLMNOPQRSTUVWXYZ
abcdefghijklmnopqrstvwxyz
1234567890&?$£

CHARACTERISTICS FOR IDENTIFICATION

square apex · 90 degree connections · notched terminal · ball teardrop · upturned ear

205

ARQGag

square serifs · hook leg · wave tail · notched spur · bowl

H&FJ SENTINEL BOOK ITALIC

ABCDEFGHIJKLMNOPQRSTUVWXYZ
abcdefghijklmnopqrstvwxyz
1234567890&?$£

CHARACTERISTICS FOR IDENTIFICATION

square apex · 15 degree slant · notched terminal · single story · no ear

ARQGag

square serifs · hook leg · wave tail · notched spur · hook tail

Script

Script

Casual Script: Home Run
Designer: Doyald Young (1926–2011)
2006: Los Angeles, California, USA

Blackletter Script: Fette Fraktur
Designer: Johann Christian Bauer
(1802–1867)
1850: Frankfurt am Main, Germany

Formal Script : Young Gallant
Designer: Doyald Young (1926–2011)
2010: Los Angeles, California, USA

Handwritten Script: FF Schulschrift
Designer: Just van Rossum (b. 1966)
1992: The Hague, Netherlands

All script typefaces are based on handwriting. However, script typefaces are divided into four categories: casual, blackletter, formal, and handwritten. Formal script is based on the work of seventeenth- and eighteenth-century handwriting masters such as Charles Snell and George Shelley. The thick and thin strokes replicate the forms drawn with a quill or metal-edged pen. Rather than appearing old-fashioned, a formal script can feel clean and crisp with contemporary typefaces such as Snell Roundhand and Young Baroque.

Casual scripts are less formal, emulating a fast and breezy handwriting. Often, when adopted for an identity, they are made of custom letters, not a typeface. They rose to prominence in the 1950s, when society moved away from the formal manners of the pre-war era and embraced a more casual lifestyle. Blackletter script typefaces are based on the calligraphy of medieval manuscripts. Handwritten script typefaces are either truly drawn by hand, or replicate the thick and thin strokes as if drawn with a brush, pencil, marker, or other media.

SUGGESTIONS FOR SUCCESSFUL APPLICATION
➥ Script typefaces applied to wedding and engagement invitations create the formal appearance of traditional handwritten invitations.
➥ Neither formal nor casual script typefaces are appropriate for text.
➥ The kerning of formal and casual scripts must be maintained to link the letters together as if handwritten.

APPLICATIONS
Coca-Cola logo
Johnson & Johnson logo
Cartier logo

POPULAR SCRIPT
TYPEFACES
Snell Roundhand
Bickham Script
Kuenstler Script
Kaufmann
Young Gallant

OPPOSITE AND FOLLOWING
Gretas
Twenty-Five Art House ~ 2016
Identity and packaging
Gretas café is located at the Haymarket hotel in Stockholm. The building was previously a famous department store. It was here that the actress Greta Garbo was discovered. The custom casual script references the building's history and Garbo's persona.

Louis Vuitton
Jean François Porchez ~ 2013
Identity
Porchez refined the forms of the classic casual script logo and created a unique typeface applied to a line of women's handbags with resort destination names such as Capri, Mykonos, and Saint Tropez.

Saks Heart
Marian Bantjes ~ 2008
Promotion
Marian Bantjes's heart is made of casual script letterforms for a Valentine's Day promotion at Saks Fifth Avenue. The intricate forms contain hidden words related to the holiday.

The Well at the World's End
Sir Edward Burne-Jones ~ 1896
Book
Paradise Lost exhibits clean and open margins in a modern translation of Renaissance ideals. The illustrated headline references Gothic blackletter, such as Fette Fraktur, and English medieval lettering.

212

THE WELL AT THE WORLD'S END
BOOK IV. THE ROAD HOME.

Chapter I. Ralph and Ursula come back again through the Great Mountains.

O THE MORROW MORNING they armed them and took to their horses & departed from that pleasant place, and climbed the mountain without weariness, & made provision of meat and drink for the Dry Desert, & so entered it, & journeyed happily with naught evil befalling them till they came back to the House of the Sorceress; and of the Desert they made little, & the wood was pleasant to them after the drought of the Desert. But at the said House they saw those kind people, & they saw in their eager eyes as in a glass how they had been bettered by their drinking of the Well, & the Elder said to them: "Dear friends, there is no need to ask you whether ye have a-chieved your quest; for ye, who before were lovely, are now become as the very Gods who rule the world. And now methinks we have to pray you but one thing, to wit, that ye will not be overmuch of Gods, but will be kind and lowly with them that needs must worship you." They laughed on him for kindness' sake, and kissed and embraced the old man, and they thanked them all for their helping, and they abode with them for a whole day in good will & love; and thereafter the carle, who was the son of the Elder, with his wife, bade farewell to his kinsmen, & led Ralph and Ursula back through the wood and over the desert to the town of the Innocent Folk. The said folk received them in all joy & triumph, & would have them a-bide there the winter over. But they prayed leave to depart, because their hearts were sore for their own land and their kindred. So they abode there but two days, and on the third day were led away by a half score of men gaily apparelled after their manner, and having with them many sumpter beasts with provision for the road. With this fellowship they came safely and with little pain unto Chestnut Vale, where they abode but one night, though to

The Art of Steel Die Engraving
Doyald Young ~ 1984
Etching
Conceived as a frontispiece for a brochure for Apex Engraving, this cartouche is a formal script similar to Young Baroque with swashes formed only from extensions of the letterforms.

Wildsam Box Set
Amy Pastre, Courtney Rowson:
SDCO Partners ~ 2017
Publication
The simple, black-and-white box opens to a broad color spectrum of individual guidebooks. The handwritten script and numbered edition add a touch of the personal.

216

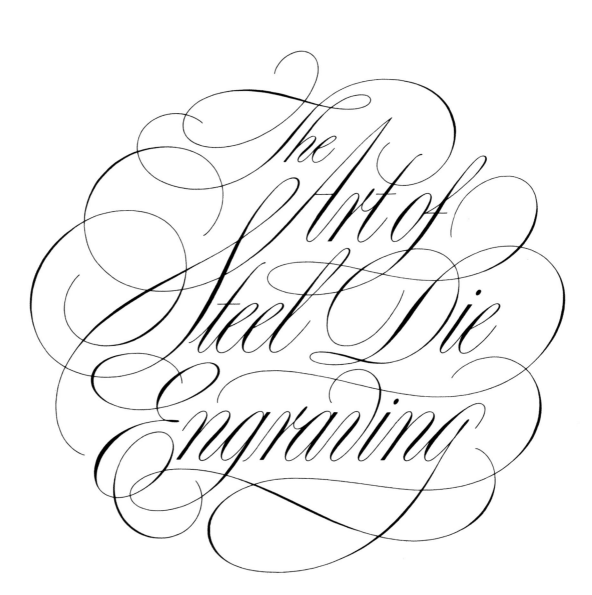

The parting of Lancelot and Guinevere

ABOVE
Alfred Tennyson's Idylls of the King
Julia Margaret Cameron - 1874
Photograph
Alfred Tennyson asked Cameron to create photographs to illustrate a new edition of his book. Cameron used her friends, family, and own costumes, noting each scene using her script handwriting.

OPPOSITE
The Blue Egyptian Water Lily
Joseph Constantine Stadler - 1804
Aquatint and stipple engraving
This delicately colored aquatint depicts a blue Egyptian water lily rising from the waters of the Nile at Aboukir Bay. A handwritten script identifies the subject.

FOLLOWING
Bonnie's Jams
Louise Fili, John Passafiume:
Louise Fili Ltd - 2013
Packaging
Bonnie's Jams is recognized as a specialist in hand-made jams, jellies, and preserves. Fili referenced alphabets and handwriting samples from the 1940s.

The_Blue Egyptian Water Lily

London Published by Dr. Thornton

Bonnie's Jams

REMEMBERING *the* TASTE OF FRUIT

Raspberry Lime Rickey

A tangy treat

ingredients: RIPE RASPBERRIES,
SUGAR, LIME *and* LEMON JUICE

Net Wt 8.75 oz (248 g) | 3092

Bonnie's Jams

REMEMBERING *the* TASTE OF FRUIT

Apricot Orange

*Tasty with toast or a
creamy cheese*

ingredients: RIPE APRICOTS, SUGAR,
ORANGES, *and* LEMON JUICE

Net Wt 8.75 oz (248 g) | 5623

Bonnie's Jams

REMEMBERING *the* TASTE OF FRUIT

Black & Blue

*Blackberries and Blueberries
in perfect balance*

ingredients: RIPE BLACKBERRIES,
BLUEBERRIES, SUGAR, *and* LEMON JUICE

Net Wt 8.75 oz (248 g) | 1407

Bonnie's Jams

REMEMBERING *the* TASTE OF FRUIT

*Strawberry
Rhubarb*

A delicious Spring mating

ingredients: RIPE STRAWBERRIES,
RHUBARB, SUGAR, *and* LEMON JUICE

Net Wt 8.75 oz (248 g) | 7231

BLACKLETTER: LINOTYPE FETTE FRAKTUR

𝕬𝕭𝕮𝕯𝕰𝕱𝕲𝕳𝕴𝕵𝕶𝕷𝕸𝕹𝕺𝕻𝕼𝕽𝕾𝕿𝖀𝖁𝖂𝖃𝖄𝖅

abcdefghijklmnopqrstvwxyz

1234567890¿?å

CHARACTERISTICS FOR IDENTIFICATION

metal calligraphic forms swash, not a lobe two pieces upturned cross bar pointed apex

sharp corners "K" shape "B" non-connecting "O" counter metal pen strokes loop

CASUAL SCRIPY: HOME RUN

ABCDEFGHIJKLMNOPQRSTUVWXYZ

abcdefghijklmnopqrstvwxyz

1234567890&?$£

CHARACTERISTICS FOR IDENTIFICATION

minimal swash paintbrush strokes 2 story "G" square terminal

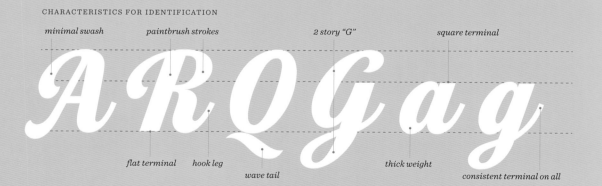

flat terminal hook leg wave tail thick weight consistent terminal on all

Specimen

FORMAL SCRIPT: YOUNG GALLANT

ABCDEFGHIJKLMNOP2RSTUVWXYZ
abcdefghijklmnopqrstvwxyz
1234567890&?$£

CHARACTERISTICS FOR IDENTIFICATION

elaborate swashes slanted stress elaborate swashes pen stroke forms square terminal narrow width

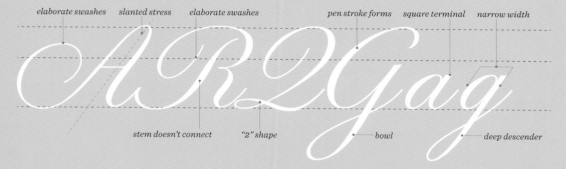

stem doesn't connect "2" shape bowl deep descender

HANDWRITTEN SCRIPT: FF SCHULSCHRIFT

ABCDEFGHIJKLMNOPQRSTUVWXYZ
abcdefghijklmnopqrstvwxyz
1234567890ß?Äe

CHARACTERISTICS FOR IDENTIFICATION

consistent stroke weight "handwritten" forms open counter cursive angle no ear

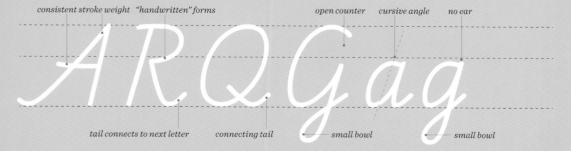

tail connects to next letter connecting tail small bowl small bowl

Decorative

PROGRAMME DES ACTIVITÉS DES MUSÉES DES ARTS DÉCORATIFS

TRANS-MISSIONS

SEPTEMBRE – DÉCEMBRE 2014

Decorative

Anisette
Designer: Jean François Porchez
(b. 1964)
1996: Paris, France

PL Behemoth
Designer: Dave West
1960: New York, New York, USA

Old Town
Designer: Dieter Steffmann
2000: Kreuztal, Germany

Taliaferro
Designer: Sean Adams (b. 1964)
2010: Los Angeles, California, USA

Decorative typefaces are not easily organized into neat categories. They have many names: display, ornamental, or headline. Headlines, large text, and ornamentation are appropriate uses for display typefaces, which are often elaborate or extreme. A thick weight may be extraordinarily thick, and a thin weight may be a hairline. Letterforms merge or read first as geometric shapes. Often, what appears to be a specific typeface is customized for a particular client or purpose.

Decorative type is a product of the Industrial Revolution. Mass production led to the proliferation of consumer goods, and these products required advertising. The previous typographic language of small serif typefaces was incompatible with this need. Initially, large wood type forms served the purpose of posters and broadsides. By the mid-twentieth century, hundreds of decorative typefaces were available for advertising. Today, these also include eccentric typefaces created as an experiment or to convey a time-specific mood.

SUGGESTIONS FOR SUCCESSFUL APPLICATION

➤➤ Display type will not work as text—ever.

➤➤ Be judicious with the use of display typefaces. They have strong personalities and are often linked to a specific era.

APPLICATIONS
Stranger Things logo
American Apparel headline type
Wonderbra logo

POPULAR DISPLAY
TYPEFACES
ITC Benguiat
ITC Bookman
ITC Grouch
ITC Tiffany

OPPOSITE
TRANS-MISSIONS
Anette Lenz: Atelier Anette Lenz ~ 2014
Booklet
Each issue of the booklet of *Trans-Missions* for the Musée des Arts Décoratifs in Paris, promotes a different typeface. Lenz adopts Anisette from Typofonderie here. Anisette is an interpretation of classic Parisian Art Deco forms and the typeface Banjo (1930).

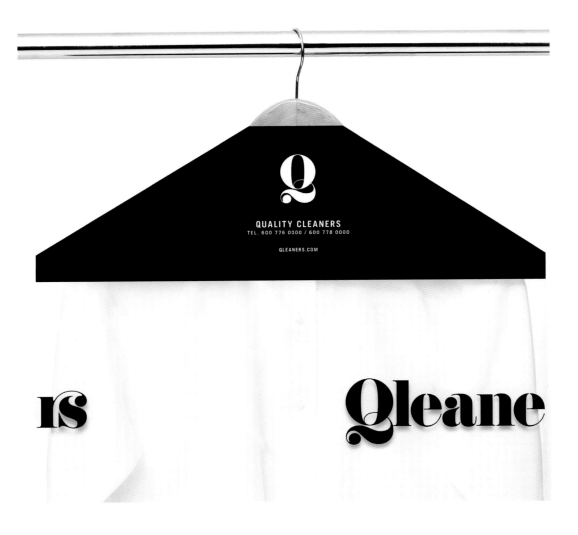

ABOVE
Qleaners
Anagrama ~ 2017
Branding
Qleaners is a company offering high-end laundry
and dry-cleaning services in Santiago de Chile.
The custom logo serif typeface, similar to
Taliaferro and Didoni, simulates organic shapes
similar to moving water.

ABOVE
Posters covering a building
Walker Evans - 1936
Photograph
A photograph of circus posters and decorative
type on a barn in South Carolina contrasts with
the bleak Depression-era setting. The heavy
letterforms are the precursor to typefaces such
as PL Behemoth.

is for Onomatopoeia

365 Typography Calendar — October page, showing Obsidian typeface numerals.

DECORATIVE

The Abecedarian Book
John Alcorn ~ 1964
Book

Alcorn's remarkable combination of
illustration and typography led to this book
subtitled, *An Alphabet Book of Big Words for
Adults with the Curiosity of Children with the
Capacity of Adults.* The letterforms are a mix
of hand-drawn and Latin Bold Condensed.

ABOVE
365 Typography Calendar
Studio Hinrichs ~ 2015
Calendar

Hinrichs' *365 Typography Calendar* calls
attention to typefaces and their creators.
Each month features a different typeface
[shown here, Obsidian], with a brief
biography of the designer.

BELOW
Narlee
Sean Adams · 2008
Skateboard deck
Skateboard slang from the 1960s and
1970s is expressed with several decorative
typefaces, including Oklahoma and Old
Town, redrawn to meld and merge together
as one unit.

232

Lederhaas Hand & Body Wash
Roland Hörmann: Phospho ~ 2014
Packaging
Phospho designed the packaging for this trio
of luxurious liquid soaps. Each of the three
scents is identified by the elaborate hand-
drawn number similar to the forms of Didoni
and Taliaferro.

233

Celler de Capçanes
Laura Meseguer, Carola Sol:
Girafa Digital ~ 2017
Packaging
Meseguer created custom lettering recalling
Didot with swash forms for the labels of
wines for aperitif or dessert: Vermut, Ranci,
and Garnatxa Dolça de Capçanes.

Paníacos
Juan Cervera, Alberto Cienfuegos, Nacho
Lavernia: Lavernia & Cienfuegos ~ 2014
Identity and packaging
The name for the bakery and café, Paníacos,
is a portmanteau play-on-words of 'bread'
and 'maniacs'. The addition of swashes to
Bodoni combines modernity and tradition.

PANACOS
LOCOS POR EL PAN

LA BAGUETTE ES UN PAN
DE ALTA COSTURA

Specimen

ANISETTE PRO THIN

ABCDEFGHIJKLMNOPQRSTUVWXYZ
ABCDEFGHIJKLMNOPQRSTVWXYZ
1234567890Ø?$!£€

CHARACTERISTICS FOR IDENTIFICATION

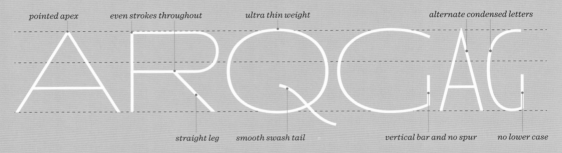

pointed apex — even strokes throughout — ultra thin weight — alternate condensed letters

straight leg — smooth swash tail — vertical bar and no spur — no lower case

ITC BEHEMOTH

ABCDEFGHIJKLMNOPQRSTUVWXYZ
abcdefghijklmnopqrstvwxyz
1234567890&?$!

CHARACTERISTICS FOR IDENTIFICATION

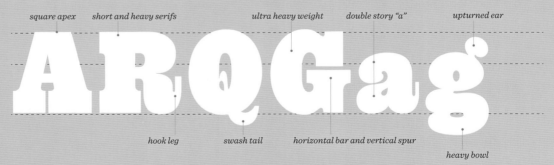

square apex — short and heavy serifs — ultra heavy weight — double story "a" — upturned ear

hook leg — swash tail — horizontal bar and vertical spur — heavy bowl

ABCDEFGHIJKLMNOPQRSTUVWXYZ
abcdefghijklmnopqrstvwxyz
1234567890&?$£

CHARACTERISTICS FOR IDENTIFICATION

flat apex condensed width tall and narrow spur double story "a" rectangular ear

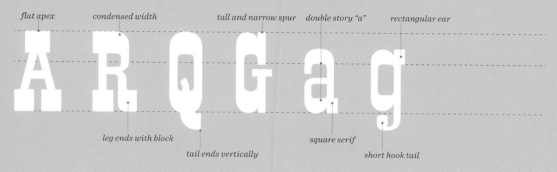

leg ends with block square serif

tail ends vertically short hook tail

ABCDEFGHIJKLMNOPQRSTUVWXYZ
abcdefghijklmnopqrstuvwxyz
1234567890&?$ſſ:

CHARACTERISTICS FOR IDENTIFICATION

square apex ultra thick and thin strokes tall spur round ball teardrop upturned round ear

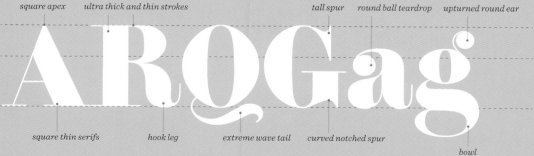

square thin serifs hook leg extreme wave tail curved notched spur

bowl

01

Digital
or Monospaced

239

Warm smell of colitas, rising up through the air

Californication
TestLab Berlin
Summer 2017

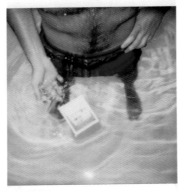

Sun-kissed skin. So hot.

Californication
TestLab Berlin
Summer 2017

If I didn't go, I could leave today

Californication
TestLab Berlin
Summer 2017

What am I doing here, I asked myself.

Warm smell of colitas, rising up through the air

Californication
TestLab Berlin
Summer 2017

Mellow out or you will pay.

Californication
TestLab Berlin
Summer 2017

How I abhor this place
Its sweet and bitter taste

Californication
TestLab Berlin
Summer 2017

Digital

Bell Gothic
Designer: Chauncey Griffith (1879–1956)
1938: New York, New York, USA

Letter Gothic
Designer: Roger Roberson (1939–2013)
1962: Lexington, Kentucky, USA

OCR-B
(Optical Character Recognition)
Designer: Adrian Frutiger (1928–2015)
1968: Paris, France

Like script typefaces, digital types have a wide range of definitions. Technically, most typefaces are digital, designed for the computer. Here, the definition applies to typefaces in the service of digital needs or type designed as a response to the freedom of digital type design. One of the earliest examples is Bell Gothic, designed in 1938. Chauncey H. Griffith designed it for printing the telephone book in tiny sizes on inferior paper. Matthew Carter later updated it as Bell Centennial.

Between 1956 and 1962, Roger Roberson designed Letter Gothic for IBM. It was intended for use on Selectric typewriters. This democratized typeface choice for the non-designer user. The digital revolution of the 1980s and 1990s spawned type specifically for low resolution on screens. Matthew Carter designed Georgia in 1993 for the Microsoft Corporation.

The introduction of the first font design program, Fontographer, in 1986 provided the tools for anyone to design a typeface. While many of the results are less than successful, some, such as Jeff Keedy's Keedy Sans, have used the software to question the history of type design and its cultural meaning. There are thousands of typefaces now designed for use on phone screens, websites, interactive kiosks, airport signage, and other screen-based media.

APPLICATIONS
Microsoft Word included fonts
Bell Telephone Yellow Pages
Burger King logo

POPULAR DIGITAL
TYPEFACES
Arial
OCR-A
Keedy Sans
Verdana

OPPOSITE
Californication
Sean Adams - 2016
Poster series
Californication was a studio to explore the California myth and its relationship to Berlin subculture and underground club life. Bell Gothic, with its neutral and industrial influenced design, is the primary typeface.

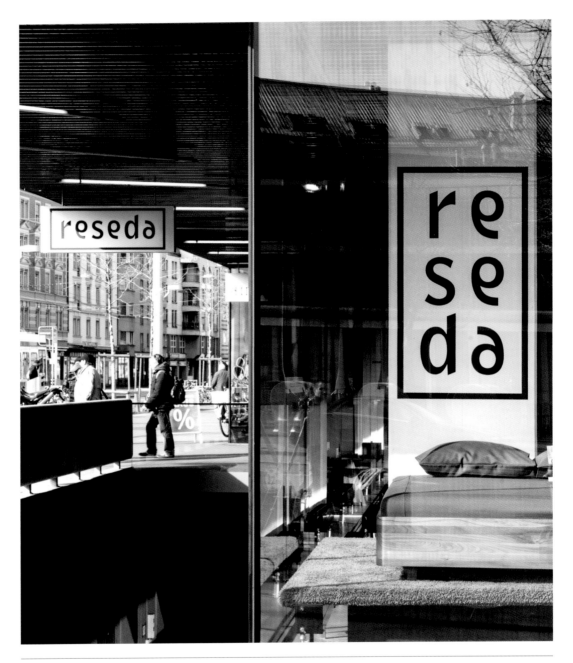

ABOVE
Reseda
Raffinerie - 2016
Identity
Reseda is a young and innovative furniture manufacturer in Zürich. Raffinerie developed the corporate identity based on Bell Gothic.

OPPOSITE
Casa Bosques Chocolates
Savvy - 2017
Packaging
Casa Bosques Chocolates is a collaboration between Savvy and the master chocolatier Jorge Llanderal. Twelve different editions are produced, one every month. The information is set simply with Letter Gothic.

SEGUNDO CHOCOLATE.
FLOR DE SAL

N°2 Edición: Primavera 2012

72% Cacao Venezolano.
Mezcla: Criollo / Trinitario

VEN: 10°29´36´´- N 67°31´38´´- 0

Hecho en San Pedro G. G.
Nuevo León - México

Desarrollado por: Savvy Studio & J. Llanderal
Diseño: http://www.savvy-studio.net

C . B . B

Av. Bosques del Valle #106, L-5
Bosques del Valle, San Pedro Garza García
Nuevo León, México / C.P. 66250
http://www.casabosques.net

CASA BOSQUES

80g / 2.84oz

ABOVE
Bildmuseet
Björn Kusoffsky, Nina Granath, Lisa Fleck,
Eva Dieker: Stockholm Design Lab - 2012
Identity and signage
The identity for the Bildmuseet arts center
communicates the idea of a place where art and
science meet. The simple monospaced alphabet,
OCR-B, is proprietary and distinctive.

ABOVE
Bigert & Bergström: Works 1986–2016
Stockholm Design Lab - 2017
Book
Swedish artist duo Bigert & Bergström's
work examines the junction between
humanity, nature, and technology using
OCR-B as a dominant typeface.

ABOVE
QTleap
P-06 Atelier ~ 2014
Identity and website
For the Faculty of Sciences of the University of Lisbon's machine translation project, P-06 designed a living identity system that is in constant flux with Simple, a variation of OCR-A.

OPPOSITE
Oasis
Soo Kim and Jennifer Sorrell ~ 2017
Poster
For the NASA missions to determine if liquid water and life exist on Jupiter's moon Europa, Kim and Sorrell used Replica Mono to create an interactive experience, with projections of typography reflected on water.

FOLLOWING
Nowy Teatr
Arkadiusz Romański: Huncwot ~ 2013
Website
Recto is the primary typeface for the Polish cultural institution Nowy Teatr. Video backgrounds with subtle changes are inspired by Andy Warhol's movies and feature the theater's director and actors.

OASIS

EXTRATERRESTRIAL WATERS

JET PROPULSION LABORATORY
& NASA PRESENT OASIS.
AN EXHIBITION PROMOTING
THE UPCOMING 2020 CLIPPER
MISSION TO EUROPA.

AT DESERT X
FREE & OPEN TO THE PUBLIC
ALL HUMANS WELCOME

SPRING 2019
COACHELLA VALLEY
CALIFORNIA, UNITED STATES

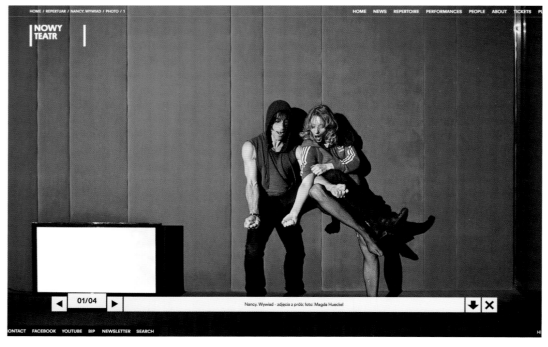

BITSTREAM BELL GOTHIC

ABCDEFGHIJKLMNOPQRSTUVWXYZ
abcdefghijklmnopqrstvwxyz
1234567890&?$!

CHARACTERISTICS FOR IDENTIFICATION

square apex consistent weight strokes condensed width double story "a" gap at connections

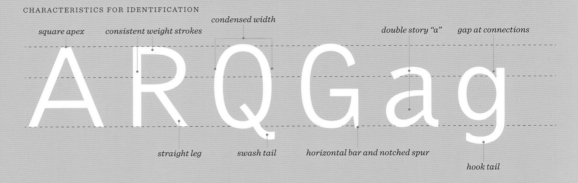

straight leg swash tail horizontal bar and notched spur hook tail

ADOBE LETTER GOTHIC

ABCDEFGHIJKLMNOPQRSTUVWXYZ
abcdefghijklmnopqrstvwxyz
1234567890&?$£

CHARACTERISTICS FOR IDENTIFICATION

pointed apex consistent weight strokes condensed width double story "a" terminal curves right

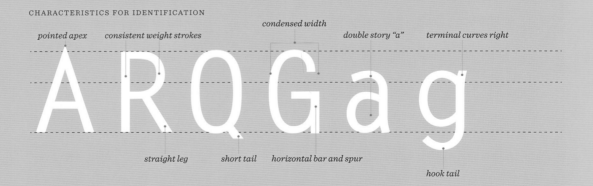

straight leg short tail horizontal bar and spur hook tail

OCR-A

ABCDEFGHIJKLMNOPQRSTUVWXYZ
abcdefghijklmnopqrstvwxyz
1234567890&?$!

CHARACTERISTICS FOR IDENTIFICATION

round apex rectangular lobe diagonal slant angled stroke double story "a" octagonal counter

ARQGag

round terminals square leg diagonal and horizontal tail no spur hook tail

OCR-B

ABCDEFGHIJKLMNOPQRSTUVWXYZ
abcdefghijklmnopqrstvwxyz
1234567890&?$£¥≠≈flπ

CHARACTERISTICS FOR IDENTIFICATION

square apex even stroke weight oval counter horizontal terminal double story "a" no ear

ARQGag

leg has no curves diagonal tail no spur hook

Contributors

Credits and Acknowledgments

"Every effort has been made to trace copyright holders and to obtain their permission for the use of copyright material. The publisher apologizes for any errors or omissions in the below list and would be grateful if notified of any corrections that should be incorporated in future reprints or editions of this book."

17, 18: Photograph credit: Martin Seck
19, 23, 38, 41, 53, 65, 66, 148-149: Courtesy of the James Lemont Fogg ArtCenter Library Collections
21: Courtesy of The Metropolitan Museum of Art, New York, Leonard A. Lauder Collection of American Posters, Gift of Leonard A. Lauder, 1984
26: Courtesy Maira Kalman
28: Courtesy Rizzoli International Publications
29, 42, 62: Courtesy ©Louis Danziger
34: Courtesy Special Collections, J. Willard Marriott Library, The University of Utah
34: Published by Typofonderie
45, 59, 121, 147, 229: Courtesy Library of Congress Prints and Photographs Division Washington, D.C.
48, 56: Courtesy Louis Danziger Archives
50, 70, 94, 95, 226: Collection of the Author
52: Photograph by Caroga Foto / carogafoto.com
54: ©Fraenkel Gallery, San Francisco
59: Photograph by ©Nigel Shafran

77: Courtesy Gerald R. Ford Presidential Museum
105: Permission granted by ©Erik Spiekermann
111: Courtesy Ann Field
118: Courtesy of the Herb Lubalin Study Center
120: Courtesy British Airways, Heritage Centre
134, 154-155, 168, 169, 202, 203: ©AdamsMorioka:
Sean Adams, Noreen Morioka, Volker Dürre, Scott Meisse,
Monica Schlaug, Nathan Stock, Terry Stone, Chris Taillon
193: Photograph by ©João Morgado
213: Permission granted by ©Marian Bantjes
214-215: Courtesy of The Metropolitan Museum of Art,
New York, Harris Brisbane Dick Fund, 1917
218: Courtesy of The Metropolitan Museum of Art,
New York, David Hunter McAlpin Fund, 1952
219: Courtesy of The Metropolitan Museum of Art,
New York,
Gift of Joyce Bullock Darrell, 2014
226: Courtesy ©Ateleier Anette Lenz
250: Anisette published by Typefonderie
232: Photograph by Caroga Foto / carogafoto.com

This book would not have been possible without the
contribution of a talented team of collaborators. First,
James Evans who saw the potential for type as a subject
following *The Designer's Dictionary of Color*, made
this edition a reality. Jacqui Sayers was immensely
helpful guiding the process and maintaining sanity.
Emily Angus added her expertise with book production
and always pushed for the highest standards. Isabel
Zaragoza was often the first point of contact with
contributors and saved me when MS Excel misbehaved.

Jennifer Sorrell researched, verified, and organized
the typographic history. Her work made an impossible
deadline possible. Several sources were extremely
helpful to find the best, and often unexpected, examples
of a specific typeface. The staff at Fonts in Use (www.
fontsinuse.com), Sam Berlow, Stephen Coles, Nick
Sherman, Rob Meek, Florian Hardwig, Matthijs Sluiter,
and Tânia Raposo, created a resource unmatched
in its breadth and quality. Paul Shaw was helpful
in identifying obscure examples. Mario Ascencio
and Rachel Julius at the ArtCenter Library helped
me discover remarkable examples in the Library's
collections. Steven Heller and Jessica Helfand were
always willing to try to find the contact information
for a designer, and proved that they do, indeed, know
everyone.

And, finally, Lou Danziger, who allowed me to work with
his professional archives and gave me access to his vast
collection of graphic design artifacts and images.

Colophon

This book was written and designed by Sean Adams in 2018. Jacqui Sayers edited the book. Jennifer Sorrell researched typographic history and collected images and examples. The primary typeface used is Sentinel, designed by Jonathan Hoefler and Tobias Frere-Jones in 2009. Egyptian or slab serif typefaces such as Clarendon designed by Robert Besley in 1845 are the precursors to Sentinel.